The Artist's Painting Library

COLOR IN ACRYLIC

BY WENDON BLAKE / PAINTINGS BY FERDINAND PETRIE

WATSON-GUPTILL PUBLICATIONS/NEW YORK

Published 1982 in the United States by Watson-Guptill Publications,
a division of Billboard Publications, Inc.,
1515 Broadway, New York, N.Y. 10036

Library of Congress Cataloging in Publication Data

Blake, Wendon.
 Color in acrylic.

 (The Artist's painting library)
 Originally published as pt. 3 of: The color book.
1981.
 1. Polymer painting—Technique. 2. Color in
art. 3. Color guides. I. Petrie, Ferdinand,
1925– . II. Title. III. Series: Blake,
Wendon. Artist's painting library.
ND1535.B54 1982 752 81-21911
ISBN 0-8230-0737-5 AACR2

Manufactured in U.S.A.

 2 3 4 5 6 7 8 9/87 86 85 84 83

CONTENTS

Color in Acrylic Painting. In comparison with oil and watercolor, which go back to earlier centuries, acrylic is still quite new, the product of twentieth century chemical research. Acrylic is so new that artists are still discovering new ways to use the medium. What's particularly fascinating about acrylic is that it can be applied in so many ways: with brush and knife like thick, opaque oil paint; blended with acrylic painting medium that makes the color behave like transparent or semitransparent oil paint; or simply diluted with water to behave like transparent watercolor. This wide range of technical possibilities can produce an equally wide range of color effects—and that's what *Color in Acrylic Painting* is really about. In the pages that follow, you'll find a brief survey of color fundamentals as they apply specifically to acrylic; then you'll learn the many ways of using acrylic to capture the colors of nature. These techniques will range from the simplest and most basic—familiar to the experienced painter in acrylic—to a variety of methods that many painters is to broaden your command of the medium and encourage you to try new ways to get fresh, exciting color.

Values. Developing a "color sense" really means developing your ability to observe, analyze, and record the colors of nature. Many experienced painters and teachers say that the most important element in "color sense" is the ability to judge the lightness or darkness of colors—that is, the ability to judge *values*. So the first section of *Color in Acrylic Painting* will teach you to look at nature as if the world contained no color at all, just shades of black, white, and varied grays. After learning to analyze the values in a variety of outdoor subjects, you'll learn how to paint your own value chart in acrylic. Then you'll be encouraged to do a series of acrylic paintings entirely in black and white—and you'll watch well-known painter Ferdinand Petrie paint two acrylic demonstrations, step-by-step, one in just three values and the other in four. Thus, you'll learn that an effective acrylic painting doesn't simply record the values of nature, but simplifies them to create an effective pictorial design.

Color Control. Each acrylic tube color has its own special way of behaving, which you'll learn by conducting a series of color mixing tests, thus producing a series of acrylic color charts that you can post on your studio wall. Having learned how acrylic colors behave in mixtures, you'll then see how they behave when you place them side by side in a painting. You'll also learn how to organize the colors in an acrylic painting so that one hue enhances another, making specific colors look brighter or more subdued, lighter or darker. Other illustrations will show you how to use acrylic color to create the feeling of three-dimensional space or color perspective; how to create color harmony; and how to capture the changing colors of morning, midday, late afternoon, and night.

Demonstrations. Too many painters find just one way of applying paint to canvas or paper, and they stick to it! Thus, they overlook the vast range of painting techniques that *could* produce far greater vitality and variety in their color. In ten step-by-step demonstrations, Ferdinand Petrie shows how to use acrylic to get a variety of color effects. These demonstrations will open your eyes to the many different ways of handling this versatile medium to produce lively color in your acrylic paintings.

Ten Acrylic Painting Techniques. Petrie begins by demonstrating what you can do with just two acrylic tube colors, plus white, to produce a range of subtle colors. The second demonstration also reveals the possibilities of a limited palette, showing how to paint a colorful picture with just the three primaries (red, yellow, blue) and white. Petrie then paints two more demonstrations that explain how to use a full palette of acrylic colors to paint a subdued picture and a richly colored picture. The next four demonstrations show the remarkable possibilities of underpainting and overpainting in acrylic: a monochrome underpainting followed by a full-color overpainting; an underpainting in limited colors followed by an overpainting in full color; a full-color underpainting followed by a full-color overpainting; and a roughly textured underpainting followed by a full-color overpainting. Then a demonstration of the wet-into-wet technique shows how to mix acrylic colors directly on the painting surface. The final demonstration shows how to use acrylic in the technique of the Impressionists, building stroke over stroke for vibrant light and color.

Light and Shade. You can't understand the behavior of color without understanding the behavior of light, so the final section of *Color in Acrylic Painting* is devoted to capturing the effects of light and shade in acrylic. You'll learn how to use acrylic to render light and shade on geometric and non-geometric forms in nature; how to render the light as it strikes the subject from different angles; how to capture the light on sunny, cloudy, overcast, and hazy days; and how to paint the various lighting effects that artists call high key, middle key, low key, high contrast, medium contrast, and low contrast.

Brushes for Acrylic Painting. Because you can wash out a brush quickly when you switch from one color to another, you'll need very few brushes for acrylic painting. Two large, flat brushes will do for covering big areas: a 1″ (25 mm) bristle brush, the kind you use for oil painting; and a soft-hair brush the same size, preferably soft nylon or oxhair. Then you'll need another bristle brush and another soft-hair brush, each half that size. For more detailed work, add a couple of round soft-hair brushes—a number 10, which is about ¼″ (6 mm) in diameter, and a number 6, which is about half as thick. If you find that you like working in very fluid color, where acrylic paint is thinned to the consistency of watercolor, it might be helpful to add a big number 12 round, soft-hair brush, either nylon or oxhair. Since acrylic painting will subject brushes to a lot of wear and tear, few artists use their expensive sables.

Painting Surfaces. If you like to work on a smooth surface, you can use illustration board, which is white drawing paper with a stiff cardboard backing. You can also use watercolor paper; the most versatile watercolor paper is moldmade 140-pound stock in the cold-pressed surface (called a "not" surface in Britain). Acrylic handles beautifully on canvas, but make sure that the canvas is coated with white acrylic paint, not white oil paint. Your art supply store will also sell inexpensive canvas boards—thin canvas glued to cardboard—that are usually coated with white acrylic, which is excellent for acrylic painting. You can create your own painting surface by coating hardboard with acrylic gesso, a thick, white acrylic paint that comes in cans or jars. For a smooth surface, brush on several thin coats of acrylic gesso diluted with water to the consistency of milk or thin cream. For a rougher surface, brush on the gesso straight from the can so that the white coating retains the marks of the brush. Use a big nylon housepainter's brush.

Drawing Board. To support your illustration board or watercolor paper while you work, the simplest solution is a piece of hardboard. Just tack or tape your painting surface to the hardboard and rest it on a tabletop—with a book under the back edge of your board so it slants toward you. You can tack down a canvas board in the same way. If you like to work on a vertical surface—which many artists prefer when they're painting on canvas, canvas board, or hardboard coated with gesso—a wooden easel is the solution. If your budget permits, you may like a wooden drawing table, which you can tilt to a horizontal, diagonal, or vertical position just by turning a knob.

Palette. One of the most popular palettes is the least expensive—a white enamel tray, which you can probably find in a shop that sells kitchen supplies. Another good choice is a white metal or plastic palette (the kind used for watercolor) with compartments into which you can squeeze your tube colors. Some acrylic painters like the paper palettes used by oil painters: a pad of waterproof pages you can tear off and discard after painting.

Odds and Ends. For working outdoors, it's helpful to have a wood or metal paintbox with compartments for tubes, brushes, bottles of medium, knives, and other accessories. You can buy a tear-off paper palette and canvas boards that fit neatly into the box. Many acrylic painters carry their gear in a toolbox or a fishing tackle box, both of which also have lots of compartments. Two types of knives are helpful: a palette knife for mixing colors; and a sharp one with a retractable blade (or some single-edge razor blades) to cut paper, illustration board, or tape. You'll also find paper towels and a sponge useful for cleaning up. Then you'll need an HB drawing pencil or just an ordinary office pencil for sketching in your composition before you start to paint. To erase the pencil lines, get a kneaded rubber eraser (called a "putty rubber" in Great Britain), which is so soft that you can shape it like clay and erase a pencil line without hurting the surface. Then, to hold down that paper or board, get a roll of 1″ (25 mm) masking tape and a handful of thumbtacks (drawing pins) or pushpins. Finally, to carry water when you work outdoors, you can take a discarded plastic detergent bottle (if it's big enough to hold a couple of quarts or liters) or buy a water bottle or a canteen in a store that sells camping supplies. For the studio, you'll need three wide-mouthed glass jars, each big enough to hold a quart or a liter.

Work Layout. Before you start to paint, lay out your supplies and equipment in a consistent way, so everything is always in its place when you reach for it. Obviously your drawing board or easel is directly in front of you. If you're right-handed, place your palette, those three jars, and a cup of medium to the right. In one jar, store your brushes, hair end up. Then fill the other two jars with clear water: one for washing your brushes and the other for diluting your colors. Also, establish a fixed location for each color on your palette. One good way is to place your *cool* colors (black, blue, and green) at one end and the *warm* colors (yellow, orange, red, and brown) at the other. Put a big blob of white in a distant corner where it won't pick up traces of the other colors.

Color Selection. The acrylic paintings in this book are all done with about a dozen colors—and fewer than a dozen in many cases. Although the leading manufacturers of acrylic colors will offer you as many as thirty inviting hues, few professionals use more than a dozen, and many get by with eight or ten. The colors listed below are really enough for many years of painting. You'll notice that most colors are in pairs—one bright and the other subdued—to give you the greatest possible range of color mixtures. The list also includes a number of optional colors you can easily do without, but which are convenient to have on hand.

Blues. Ultramarine blue is a dark, rather muted blue that seems to have a hint of violet. The second blue, phthalocyanine blue, is cooler, far more brilliant, and so powerful that it's apt to dominate any mixture with another color—so it's important to add it in tiny quantities until you get the mixture you want. A third blue—in the optional category—is cerulean blue, a lovely, airy hue that's a favorite for skies and atmospheric effects.

Reds. Cadmium red light is a fiery hue that contains a hint of orange and has tremendous tinting strength—which means that a little goes a long way when you mix it with another color. So add it cautiously. Naphthol crimson is a darker red with a slightly violet cast. When you blend these two reds, you get the most vivid mixture your palette makes.

Yellows. Cadmium yellow light is a luminous, sunny yellow with the same terrific tinting strength as the other cadmiums. In contrast, yellow ochre (sometimes called *yellow oxide*) is a soft, tannish tone that produces lovely, subdued mixtures.

Green. Since you can mix so many different greens by combining the blues and yellows on your palette—or black and yellow—a tube green is really optional. However, phthalocyanine green is a clear, brilliant hue that many acrylic painters include in their palettes. Like phthalocyanine blue, the green has great tinting strength and tends to dominate mixtures, so add it very gradually.

Orange. It's so easy to mix a variety of oranges—by combining reds and yellows—that a tube of orange is really optional. But if you feel the need for a bright orange on your palette, get cadmium orange.

Browns. Burnt umber is a dark, subdued brown that appears on practically every artist's palette. Burnt sienna is a coppery brown—so bright and warm that it's almost an orange.

Black and White. The paintings here contain ivory black, which has slightly less tinting strength than Mars black. But you can buy either one. Titanium white is the standard acrylic white.

Gloss and Matte Mediums. Although you can simply thin acrylic tube color with water, most manufacturers produce liquid painting mediums for this purpose. Gloss medium will thin your paint to a delightful, creamy consistency; if you add enough medium, the paint turns transparent and allows the underlying colors to shine through. As its name suggests, gloss medium dries to a shiny finish like an oil painting. Matte medium has exactly the same consistency and will also turn your color transparent if you add enough medium, but it dries to a satin finish with no shine. Try both mediums and see which you prefer. It's a matter of taste.

Gel Medium. Still another medium comes in a tube and is called gel because it has a consistency like thick, homemade mayonnaise. The gel looks cloudy as it comes from the tube, but dries clear. Blended with tube color, gel produces a thick, juicy consistency that's lovely for heavily textured brush and knife painting.

Modeling Paste. Even thicker than gel is modeling paste, which comes in a can or jar and has a consistency more like clay because it contains marble dust. You can literally build a painting ¼″ to ½″ (6 to 13 mm) thick if you blend your tube colors with modeling paste. But build gradually in several thin layers, allowing each one to dry before you apply the next, or the paste will crack.

Retarder. One of the advantages of acrylic is its rapid drying time, since it dries to the touch as soon as the water evaporates. However, if you find that it dries *too* fast, you can extend the drying time by blending retarder with your tube color.

Combining Mediums. You can also mix your tube colors with various combinations of these mediums to arrive at precisely the consistency you prefer. For example, a 50–50 blend of gloss and matte mediums will give you a semi-gloss surface. A combination of gel with one of the liquid mediums will give you a juicy, semi-liquid consistency. A simple mixture of tube color and modeling paste can sometimes be a bit gritty; this very thick paint will flow more smoothly if you add some liquid medium or gel. To create a roughly textured painting surface, you can combine acrylic gesso with modeling paste, and brush the mixture over a sheet of hardboard with a stiff housepainter's brush.

Talking About Color. When artists discuss color, they use a number of words that may or may not be familiar to you. Because many of these words will appear in this book, this page will serve as a kind of informal glossary of color terms.

Hue. When you talk about color, the first thing you'll probably do is talk about its hue. That is, you'll name the color. You'll say that it's red or blue or green. That name is the *hue*.

Value. As you begin to describe that color in more detail, you'll probably say that it's dark or light or something in between. Artists use the word *value* to describe the comparative lightness or darkness of a color. In judging value, it's helpful to pretend that you're temporarily colorblind, so that you see all colors as varying tones of black, gray, and white. Thus, yellow becomes a very pale gray—a light or high value. In the same way, a deep blue is likely to be a dark gray or perhaps black—a low or dark value. And orange is probably a medium gray—a middle value.

Intensity. In describing a color, artists also talk about its comparative intensity or brightness. The opposite of an intense or bright color is a subdued or muted color. Intensity is hard to visualize, so here's an idea that may help: pretend that a gob of tube color is a colored light bulb. When you pump just a little electricity into the bulb, the color is subdued. When you turn up the power, the color is more intense. When you turn the power up and down, you don't change the hue or value—just the brightness or *intensity*.

Temperature. For psychological reasons that no one seems to understand, some colors look warm and others look cool. Blue and green are usually classified as cool colors, while red, orange, and yellow are considered warm colors. Many colors can go either way. A bluish green seems cooler than a yellowish green, while a reddish purple seems warmer than a bluish purple. And there are even more subtle differences: a red that has a hint of purple generally seems cooler than a red that has a hint of orange; a blue with a hint of purple seems warmer than a blue that contains a hint of green. All these subtle differences come under the heading of *color temperature.*

Putting It All Together. When you describe a color, you generally mention all four of these factors: hue, value, intensity, and temperature. If you want to be very technical, you might describe a particular yellowish green as "a high-value, high-intensity, warm green." Or you might say it more simply: "a light, bright, warm green."

Primary, Secondary, and Tertiary Colors. The primaries are blue, red, and yellow—the three colors you can't produce by mixing other colors. To create a secondary, you mix two primaries: blue and red to make violet; blue and yellow to make green; red and yellow to make orange. The six tertiary colors are blue-green, yellow-green, blue-violet, red-violet, red-orange, and yellow-orange. As you can guess, the tertiaries are created by mixing a primary and a secondary: red and orange produce red-orange, yellow and orange produce yellow-orange, etc. You can also create tertiaries by mixing uneven amounts of two primaries: a lot of red and a little yellow will make red-orange; a lot of blue and a little yellow will make blue-green, and so forth.

Complementary Colors. The colors that are opposite one another on the color wheel are called *complementary colors* or just *complements*. As you move your eye around the color wheel, you'll see that blue and orange are complements, blue-violet and yellow-orange are complements, violet and yellow are complements, and so forth. Memorize these pairs of complementary colors, since this information is useful in color mixing and in planning the color scheme of a painting. One of the best ways to subdue a color on the palette—to reduce its intensity—is to add a touch of its complement. On the other hand, one of the best ways to brighten a color in your painting is to place it next to its complement. Placing complements side by side is also one of the best ways to direct the viewer's attention to the center of interest in a painting, since this always produces a particularly vivid contrast.

Analogous Colors. When colors appear next to one another—or fairly close—on the color wheel they're called *analogous* colors. They're considered analogous because they have something in common. For example, blue, blue-green, green, and yellow-green are analogous because they *all* contain blue. Planning a picture in analogous colors is a simple, effective way to achieve color harmony.

Neutral Colors. Brown and gray are considered neutral colors. A tremendous variety of grays and browns—which can be quite colorful in a subtle way—can be mixed by combining the three primaries or any pair of complements in varying proportions. For example, various combinations of reds and greens make a diverse range of browns and grays, depending upon the proportion of red and green in the mixture.

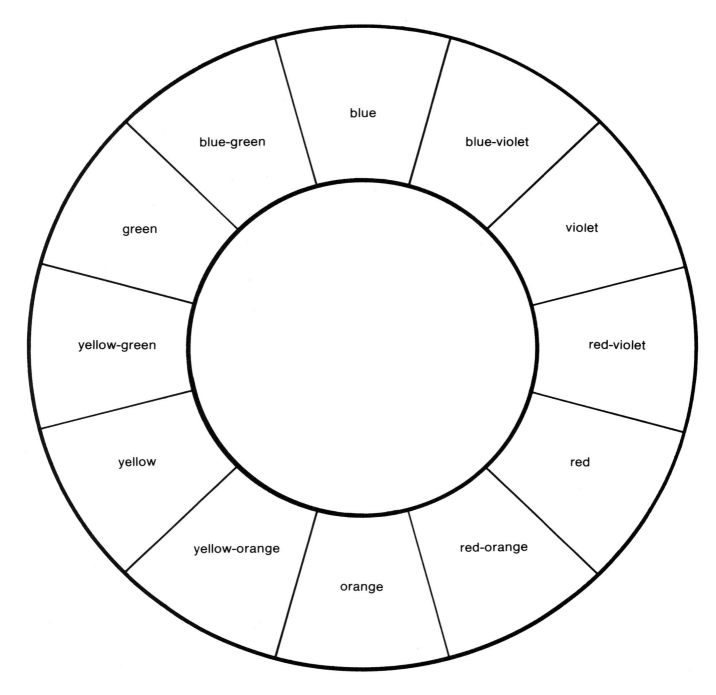

Classifying Colors. It's helpful to memorize the classic diagram that artists call a *color wheel*. This simple diagram contains the solutions to a surprising number of color problems you may run into when you're working on a painting. For example, if you want a color to look *brighter*, you'd place a bit of that color's complement nearby to strengthen it. You'll find the complement directly across the wheel from the other color. On the other hand, if you want to *subdue* that original color, you'd blend a touch of its complement into the original color. If color harmony is your problem, one of the simplest ways to design a harmonious color scheme is to choose three or four colors that appear side-by-side on the color wheel, and build your painting around these *analogous* colors. Then, to add a bold note of contrast, you can enliven your color scheme by introducing one or two of the complementary colors that appear on the opposite side of the wheel from the original colors that you've chosen for your painting.

Plan Your Mixtures. Certainly the most important "rule" of color mixing is to plan each mixture before you dip your brush into the wet colors on your palette. Don't poke your brush into various colors and scrub them together at random, adding a bit of this and a bit of that until you get what you want—more or less. Instead, at the very beginning, you must decide which colors will produce the mixture you want. Try to limit the mixture to just two or three tube colors plus white—or water if you're working with watercolor—to preserve the brilliance and clarity of the mixture.

Don't Overmix. No one seems to know why, but if you stir them around too long on the palette, colors *lose* their brilliance and clarity. So don't mix your colors too thoroughly. As soon as the mixture looks right, stop.

Work with Clean Tools. To keep each mixture as pure as possible, be sure your brushes and knives are clean before you start mixing. If you're working with oil paint, rinse the brush in solvent and wipe it on a scrap of newspaper before you pick up fresh color or, better still, try mixing with a palette knife, wiping the blade clean before you pick up each new color. If you're working with watercolor or acrylic, rinse the brush in clean water, making sure to replace the water in the jar as soon as it becomes dirty.

Getting to Know Your Medium. As you experiment with different media, you'll discover that subtle changes take place as the color dries. When you work in oil, you'll discover that it looks shiny and luminous when it's wet, but often "sinks in" and looks duller after a month or two, when the picture is thoroughly dry. Some painters restore the freshness of a dried oil painting by brushing or spraying it with retouching varnish. A better way is to use a resinous medium—damar, mastic, copal, or alkyd—when you paint. A resinous medium preserves luminosity because it's like adding varnish to the tube color. If you're working in watercolor, you'll find that watercolor becomes paler as it dries. To make your colors accurate, you'll have to make all your mixtures darker than you want them to be in the final picture. And if you're using acrylic, you'll discover that, unlike watercolor, acrylic has a tendency to become slightly more subdued when it dries. So you may want to exaggerate the brightness of your acrylic colors as you mix them.

Lightening Colors. The usual way to lighten oil color is to add white, while the usual way to lighten watercolor is simply to add water. If you're working with acrylic, you can do both: you can add white to lighten an opaque mixture and water to lighten a transparent one. However, it's not always that simple. White may not only lighten the color; it may actually change it. For example, a hot color like cadmium red light rapidly loses its intensity as it gets paler, so it may be a good idea to restore its vitality by adding a touch of a vivid color (like alizarin crimson) in addition to white or water. If the crimson turns your mixture just a bit too cool, you may also want to add a speck of cadmium yellow. In other words, as you lighten a color, watch carefully and see if it needs a boost from some other hue.

Darkening Colors. The worst way to darken any color is by adding black, because it tends to destroy the vitality of the original hue. Instead, try to find some other color that will do the job. For example, try darkening a hot red or orange—such as cadmium red light, alizarin crimson, or cadmium orange—with a touch of burnt umber or burnt sienna. Or darken a brilliant hue like cadmium yellow light by adding a more subdued yellow like yellow ochre. Although darkening one rich color with another may produce slight changes in hue or intensity, this is preferable to adding black.

Brightening Colors. Experimentation is the only way to find out how to brighten each color on your palette, since every color behaves in its own unique way. For example, a touch of white (or water) will make cadmium yellow light look brighter, while that same touch of white will make cadmium orange look more subdued. As it comes from the tube, cadmium red light looks so brilliant that it's hard to imagine any way to make it look brighter, but a touch of alizarin crimson will do it. Ultramarine blue looks dull and blackish as it comes from the tube, yet a touch of white (or water) will bring out the richness of the blue. It will become even brighter if you add a tiny hint of green.

Subduing Colors. Again, the first rule is to avoid black, which *will* subdue your color by reducing it to mud. Instead, look for a related color, one that's less intense than the color you want to subdue. The color tests described in the oil, watercolor, and acrylic parts of this book will show you how each color behaves when it's mixed with every other color on your palette. The texts should also help you decide which color to choose when you want to lessen another color's intensity. For example, a touch of yellow ochre is often a good way to reduce the intensity of the hot reds, oranges, and yellows. And a speck of burnt umber will reduce the intensity of blue without a major color change.

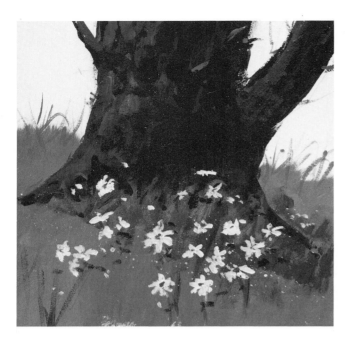

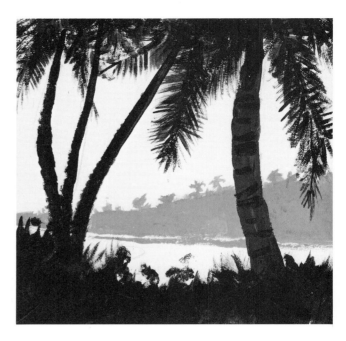

Wildflowers and Tree. Before you start to paint in color, try making a series of little paintings in black-and-white. This will teach you to judge *values*—the comparative lightness or darkness of the colors of nature. Seen as values, this green grass is a medium gray, the dark brown tree trunk is almost black, and the pale yellow wildflowers are white.

Palms. In the brilliant light of the tropics, value contrasts are particularly strong. In this monochrome painting, the sunny sky is virtually white, the silhouettes of the palms are almost black, and the distant shore is a medium gray. Note that all four paintings on this page are done in just three values—yet they easily communicate the tones of the subject.

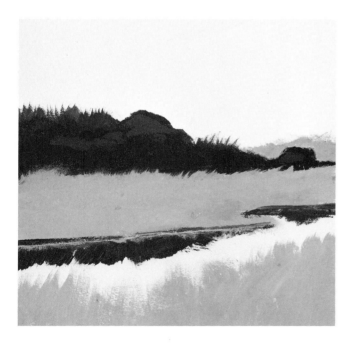

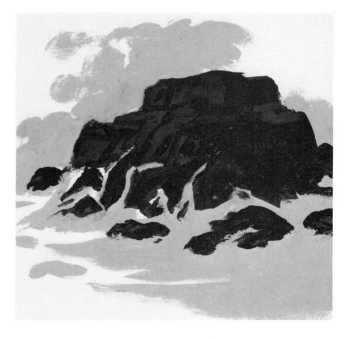

Meadow and Pond. The pale blue sky and its reflection in the water are practically white. The silhouettes of the dark green foliage and the dark brown rocks become practically black—and so does the reflection at the edge of the water. The green of the meadow and the darker tone of the water are both medium gray.

Rock and Waves. When you view this coastal subject as if you're looking at a black-and-white snapshot, you see the purplish brown of the rocks as blackish gray, the bluish shadows on the foam and water become light gray, while the pale blue sky and the pale blue water in the lower left seem almost white.

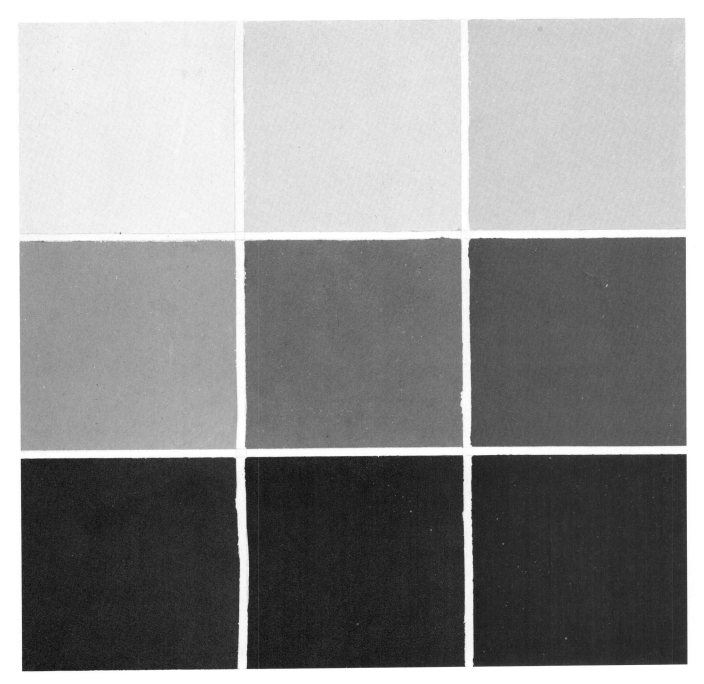

Classifying Values. Painters usually begin mixing a color by looking carefully at the subject and determining its precise value. Thus, it's enormously helpful to have a value scale on your studio wall. To paint such a chart, draw a checkerboard of nine squares on a sheet of illustration board, or on smooth, heavy drawing paper. Then mix the various tones with ivory black and titanium white. Paint the nine values as you see them here, starting with the palest tone at the upper left and gradually darkening each square until you get to pure black at the lower right. (Actually, this scale includes ten values if you include the white surface of the illustration board.) Com-

pared with the diversity of nature, you may wonder if these ten values are enough—but you'll find that every color in nature comes *reasonably* close to one of the ten values on the scale. The job of painting those nine squares looks easy, but it isn't. You'll probably have to paint and repaint most of the squares several times, adding a bit more white or black to each mixture until you get the values exactly right. Don't worry if the chart isn't absolutely neat. (The edges of some of these boxes are a bit ragged.) The main thing is to get the values right—and commit them to memory.

Step 1. Professional artists always simplify the values of nature—often to just three values, as in this demonstration painting of strawberries in a basket. After making a pencil drawing on a sheet of illustration board, the artist blocks in his darkest tones with ivory black and just a speck of white. Having painted the dark background tone in the upper right, the shadows inside the basket, the dark cracks in the basket, and the small shadows on the table, he's established *two* of the three major values in the painting. The bare, untouched surface of the illustration board represents the lightest tone, while all the other areas represent the darkest tone in the picture.

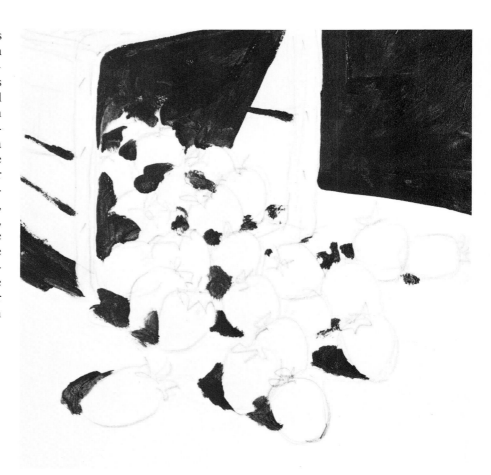

Step 2. The third and remaining value is a *middletone*. The artist brushes a mixture of black and white loosely over the basket, working carefully around the darks, and also leaving the lighted edges of the basket untouched. In the same way, he blocks in the strawberries, leaving the small patches of shadow untouched, and also leaving bare illustration board for the stems of the berries. By the end of Step 2, we can see all three major values: a *dark* from the lower part of the value scale, a *light* from the upper part, and a *middletone* from the central area of the scale. The basic design of the picture is there, and the artist can now concentrate on details.

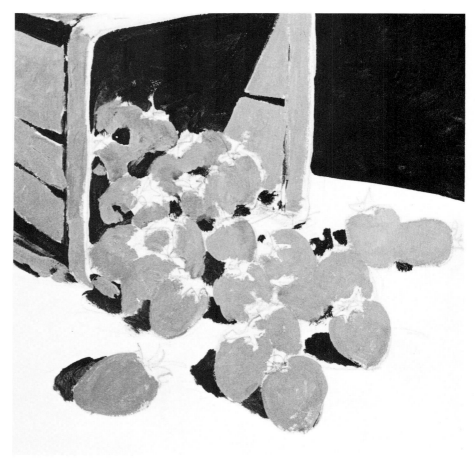

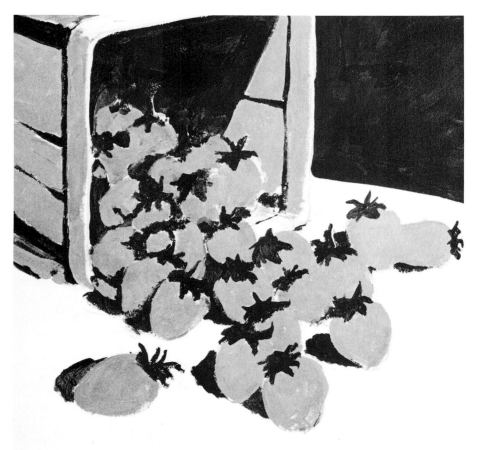

Step 3. The artist uses his dark value to paint the stems of the berries. Like the dark in Step 1, this is mainly black with just a little white and enough water to make the paint flow smoothly. In the actual subject, the darks of the wall in the upper right, the shadows on the basket, the smaller shadows on the table, and the stems of the berries are all different colors and *aren't* exactly the same value. But they're all close to one another in value, so the artist simplifies them all to the same dark tone. In the same way, the basket and berries are actually different colors and not exactly alike in value, but they're close enough to be painted the same middletone. The artist knows that simplifying values makes a bolder, more convincing picture.

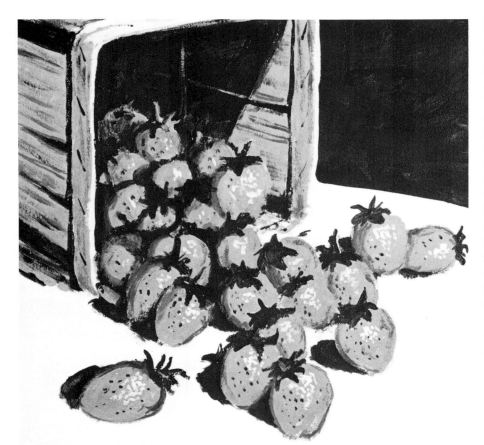

Step 4. The artist works mainly with the three major values when he adds final details and textures. Slender lines of the darkest value suggest the texture of the basket. Tiny touches of the same dark, plus dots of the lightest value, indicate the texture of the berries. Along the edges of the berries, just a few strokes of a second, slightly darker middletone are added to make the forms more three-dimensional. A few strokes of this second middletone also appear on the basket. But this second middletone is so inconspicuous that the basic three-value scheme is unchanged. Look at the finished study with half-closed eyes, and you'll see that virtually the entire picture is painted with a dark, a light, and one dominant middletone.

Step 1. There are many times when four values—not just three—will do the job most effectively. This demonstration painting of a mountainous landscape demands a dark, a light, and *two* middletones (one darker and one lighter). The pencil drawing defines the mountains, the slopes below, the masses of trees below the slopes, and the strip of water at the bottom. Within the mountainous shapes, pencil lines also define the light and shadow planes. The sky is the lighter of the two middletones, and this tone is reflected in the lake at the bottom of the picture. The artist blocks in both areas with ivory black, plenty of titanium white, and water.

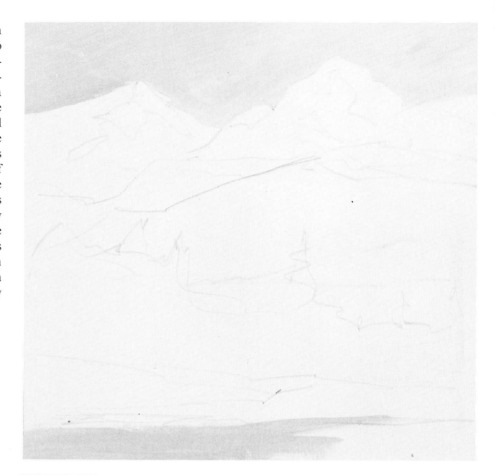

Step 2. The artist decides that it's important to establish a distinction between the two middletones as early as possible. So he blocks in the shadow planes on the mountains and on the tree-covered slopes below with a *darker* middletone—more black and less white. This same tone reappears on the shore at the edge of the lake, and in a dark reflection in the water at the lower right. (These last few strokes turn out to be too dark, but the artist easily corrects them with additional strokes of opaque acrylic when Step 2 is dry.) Finally, he adds some strokes of the lighter middletone to suggest paler shadows on the snow on the mountains.

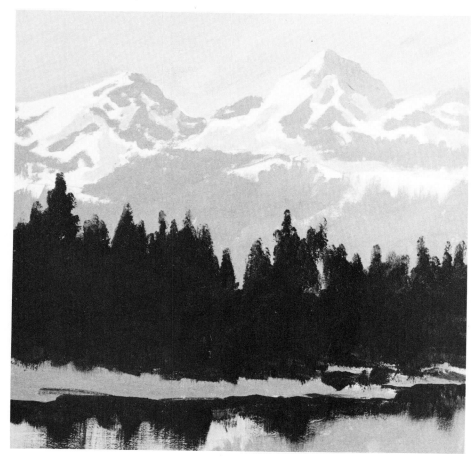

Step 3. By the end of Step 2, we can see three of the four major values: the bare board that represents the lightest tone, from the upper part of the value scale; a pale middletone, only a bit further down on the scale; and a darker middletone from the central area of the scale. Now the artist completes the four-value scheme by painting the trees and their reflections with a dark tone from the lower part of the scale. (He's also corrected the tones that were too dark at the bottom of the picture in Step 2.) These dark masses—the trees and their reflections—are almost pure black, with just a hint of white—and very little water, so the paint is thick and the strokes have a rough texture that you can see most clearly at the tops of the trees and in the reflections at the lower left.

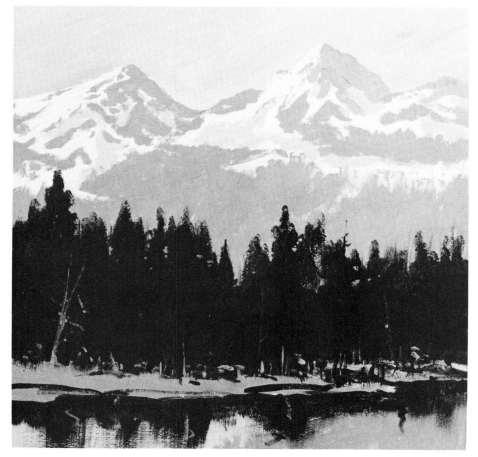

Step 4. A slender, round brush picks up the darker middletone to suggest a few trunks among the dark mass of the trees, and to add the pale reflections of these trunks in the dark water. Rinsing the brush, he uses it again to add a few dark branches above the trees, some dark trunks and shadows below, and the dark reflection of a trunk in the water at the lower right. Moving up to the mountains, he uses the darker middletone to add more shadow planes on the snowy slopes. (These strokes are most obvious on the peak in the upper left.) The finished painting, done entirely with mixtures of ivory black and titanium white, shows how just four values can render a rich, complex pattern of light and shade, while creating a strong sense of space and atmosphere.

Getting to Know Acrylic Colors. As you squeeze acrylic color from the tube, it's a thick paste similar to oil paint. If you add just a bit of water, liquid acrylic medium, or gel medium, the paint becomes creamy. This consistency lends itself to a technique somewhat like oil painting—thick strokes of solid, opaque color—although acrylic dries far more rapidly than oil paint and has its own special handling qualities, as you'll see when you watch the painting demonstrations. Acrylic paint is highly versatile. If you add a lot more liquid painting medium or gel medium, the color turns transparent, like oil paint that's been diluted with a lot of medium, or like a thick version of watercolor. And if you just add a lot of water to acrylic color, the result is a highly fluid consistency that looks and handles like transparent watercolor. It's important to get to know the different ways of handling acrylic color so you can take full advantage of the range of techniques that are possible with this remarkable medium.

Making Color Charts. To understand how acrylic colors work, make a series of color charts. Because acrylic will stick to any surface that's not oily or greasy, work on illustration board, canvas-textured paper that's made for oil and acrylic painting, canvas boards, or small scraps of canvas cut to a size similar to the page you're now reading. To begin, use a sharp pencil and a ruler to make a checkerboard pattern of boxes, each about 2" to 3" (50 to 76 mm) square. For each color on your palette, make a separate chart with about a dozen boxes so you'll have room to mix that color with all of the others. In the boxes, write the names of the colors used to make the mixtures.

Adding White. Many of your mixtures will require white, so it's essential to find out how each of your acrylic tube colors behaves when white is added. Therefore, the first stage in making your chart is to brush a few broad strokes of the tube color—diluted with just a touch of water to make the color creamy—into its own box on the chart. While the first strokes are still wet, pick up a brushload of pure white and blend it into half of the wet color in the box. Let the sample dry. When you've done this with each tube color, you'll see that some colors, like cadmium red light and cadmium orange, are brightest when they come from the tube and quickly lose their intensity as soon as you add even a small amount of white. Other colors, like the blues and greens, tend to look murky as they come straight from the tube, but suddenly come to life and reveal their richness when you add a touch of white. Also watch the subtle changes that take place

in color temperature: alizarin crimson, for example, becomes distinctly cooler when you add white.

Mixing Two Colors. Next, you're going to mix every tube color with every other tube color. Once again, add just a touch of water to each color to produce a creamy paint consistency. In each box on your color chart, make a pair of broad, juicy strokes, one stroke for each color. Angle the strokes so that they converge. Where they meet and overlap, blend the two colors together in a circular patch. Now you can see the original two colors, plus the mixture that they make. If you have the patience, you may want to conduct this series of tests with two different paint consistencies: thick, creamy color that's diluted with a small amount of water; and thin, transparent color that's diluted with lots of water. When the samples are dry, analyze and compare the mixtures. You'll see that cadmium yellow and ultramarine blue produce a much softer green than cadmium yellow and phthalocyanine blue. And when you mix yellow ochre and ultramarine blue, you'll get a green that's softer still. When you're working with thick, opaque colors, a mixture may look dull until you add a speck of white—so don't hesitate to add some white to bring out the full color.

Optical Mixing. When you add a lot of liquid acrylic medium, gel medium, or just plain water, acrylic tube color turns transparent. This gives you an opportunity to try a kind of color mixing—called *glazing*—that accounts for the luminous colors of the Old Masters. First add just a bit of white to each tube color and brush a few broad strokes of each into a separate box, allowing some extra white space at the right. When these strokes are dry, dilute another color to a transparent consistency—called a *glaze*—with liquid or gel medium, or water, and brush this mixture into the box so that it covers some of the white space and some of the dried color. When this glaze is dry, you'll have three parallel bands of color. At either side, you'll find the two original colors. Where they meet and overlap, you'll find a third color—an *optical mixture* of the two. (It's considered an optical mixture because the two colors aren't physically blended on the palette to make a third color, but remain two separate layers of paint that "mix" in the viewer's eye.) Now make these optical mixtures with all the tube colors on your palette. When you compare the optical mixtures with the physical mixtures, it's surprising how different they look. Sometimes the physical mixture is brighter, sometimes the optical mixture seems clearer and more luminous, and sometimes the optical mixture is quite a different color.

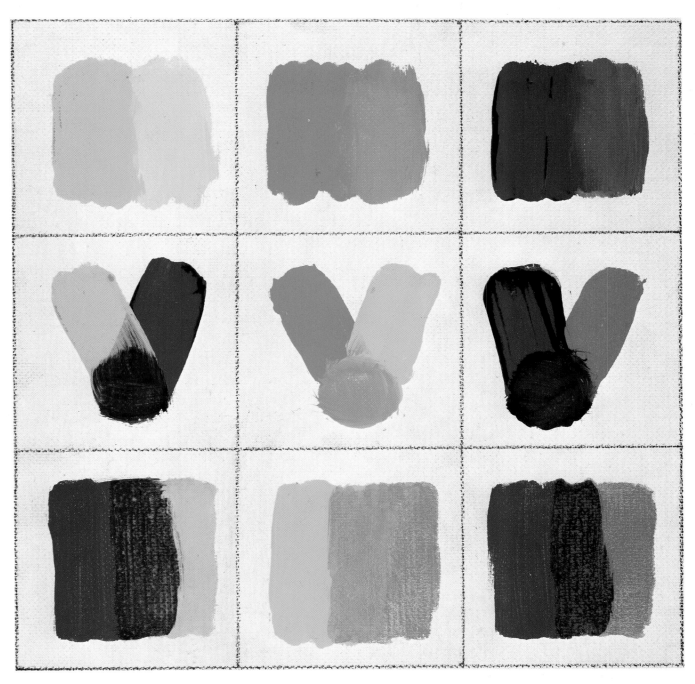

Exploring Color Mixtures. Here are some typical boxes selected from various color charts. Since titanium white will appear in most opaque mixtures, start out by mixing each tube color with white, as it's done in the top row. Looking from left to right, you see cadmium yellow light, cadmium red light, and ultramarine blue—straight from the tube and then blended with white. The second row shows how to mix every color on your palette with every other color. From left to right, a stripe of cadmium yellow light meets a stripe of ultramarine blue, cadmium red light meets cadmium yellow light, and ultramarine blue meets cadmium red light. The second row shows *physical* mixtures, where two colors are brushed together to make a third. The bottom row shows *optical* mixtures, when you thin a color to a transparent *glaze* with painting medium or water, then brush it partially over a dried patch of another color. From left to right, transparent cadmium yellow light is brushed over ultramarine blue, transparent cadmium red light is brushed over cadmium yellow light, and transparent cadmium red light is brushed over ultramarine blue. In an optical mixture, one color shines through another color to create a third. Also try adding water or painting medium—instead of white—to the mixtures in the first and second rows.

Complementary Background. The hot color of the melon is a mixture of cadmium red light and naphthol crimson. (The two bright reds on your acrylic palette make an even brighter red when you blend them.) The color of the melon *starts* out looking brilliant, of course, but it will look even more brilliant if you place it against green, the complement of red on the opposite side of the color wheel. The cool background color is a mixture of phthalocyanine blue and cadmium yellow light, and just a bit of burnt umber.

Analogous Background. On the color wheel, the colors on each side of any color are called analogous colors. Therefore red-orange and yellow-orange are both analogous to red—*related* to red—for the obvious reason that they *contain* red. Placed against an analogous background color, the hot color of the melon doesn't stand out as strongly as it did against the complementary background of the previous example. Instead, the melon and the background harmonize, rather than contrast. The warm color of the background is a mixture of cadmium red light and cadmium yellow light, softened with just a little burnt umber.

Neutral Background. Still another way to make the hot color of the melon sing out is to place it against a subdued color, called a *neutral.* When placed against neutrals—grays, tans, blue-grays, browns, and gray-browns—every bright color looks dramatic. Here, the background is a blend of ultramarine blue, burnt umber, and white. Remember, there's no "ideal" background for this melon or for any other color. Your choice of background color depends on what you want to accomplish in the picture. To make a color look brighter, place it against a complementary or neutral background. To make a color appear more subdued, place it against an analogous background.

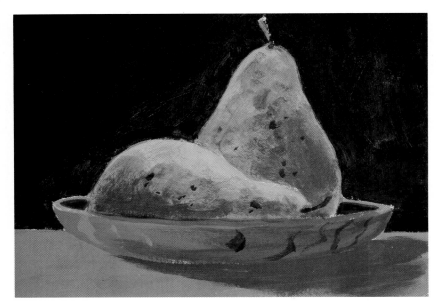

Dark Background. Value, like color, is a matter of *relationships.* These pears look both light and bright because the artist has placed them against a dark background that dramatizes the paler tones of the fruit. The lighted areas of the pears are painted with cadmium yellow light, just a speck of ultramarine blue, and lots of white. The shadowy areas of the pears are painted with the same mixture, but it contains more ultramarine blue. The dark background color is phthalocyanine blue and burnt sienna.

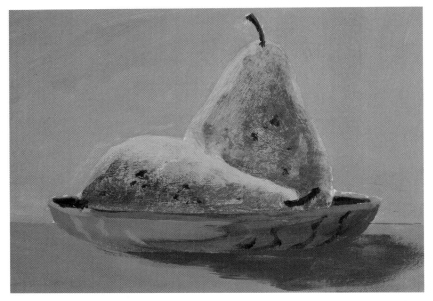

Middletone Background. The same pears don't look as light *or* as bright when the artist places them against a background that's much closer in value to the pears. In fact, the pears look slightly darker against the middletone background than they look against the dark background in the picture above. The color mixtures in the pears are exactly the same. The background mixture is ultramarine blue, burnt umber, and white. The neutral table, by the way, is also the same mixture as the background, but with more burnt umber.

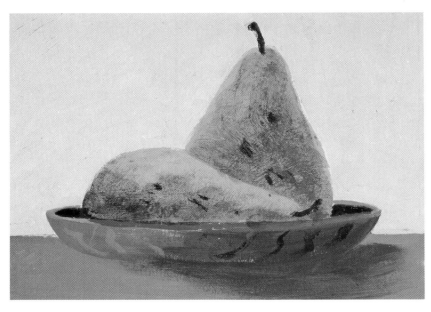

Light Background. When the artist places the pears against a pale value, they also stand out against the background. But now they stand out because they look *darker* than the background. The color mixtures in the pears are still the same, but now the background is ultramarine blue and lots of white, with just a hint of burnt sienna. Look at these three studies of the pears with half-closed eyes and you'll see the "rules" for controlling value relationships. To make a color look lighter, place it against a dark background. To make a color look less prominent, place it against a background of similar value. And to make a color look darker, place it against a lighter background.

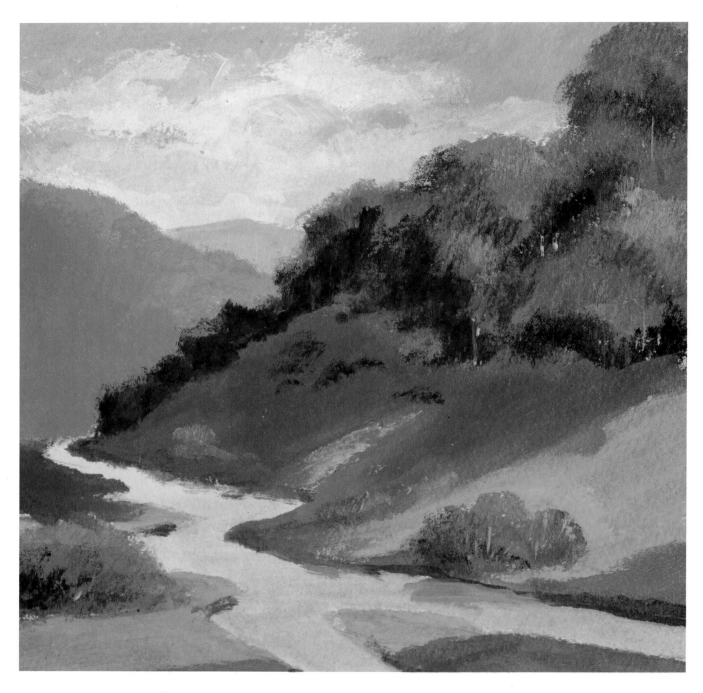

Sunny Day. You've probably seen perspective diagrams that show how parallel lines tend to converge as they recede toward the horizon. That's what's happening with the zigzag shape of the stream, whose banks move closer together as the stream moves away from the foreground. But *color* also creates a strong feeling of perspective. In a sunny landscape like the one you see here, colors tend to be brighter and warmer in the foreground, where there are also stronger tonal contrasts. As objects become more distant, their colors gradually become paler and cooler, with less contrast. Thus, warm, sunlit patches contrast with strong, rich shadows in the foreground of this landscape. But on the more distant slope at the left, the color is paler, cooler, and more subdued, with just a subtle value change to suggest the contrast between light and shadow. And the tiny, distant peak at the center of the picture is still paler and cooler—there are no lights and shadows on the mountain at all. The sky obeys the same "rules" of *aerial perspective.* Directly overhead, at the top of the picture, the sky is both darker and brighter than the more distant sky at the horizon. This acrylic painting is executed on cold-pressed watercolor paper. You can see the texture of the paper in the trees. The sunlit slopes and foliage in the foreground are all mixtures of phthalocyanine blue, cadmium yellow light, burnt sienna, and white, with more yellow in the sunlit areas, and more blue and burnt sienna in the shadows.

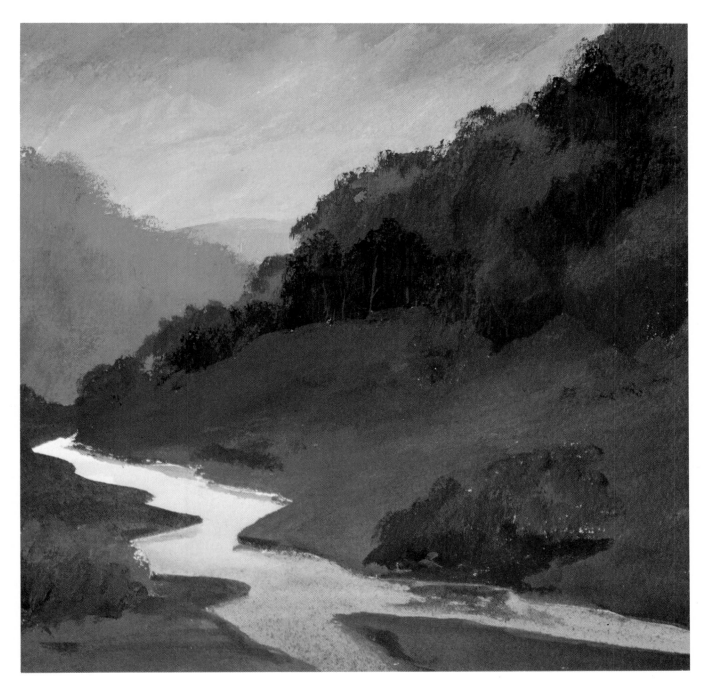

Overcast Day. Although the colors of this landscape are more subdued on a gray day, the colors still obey the same "rules" of aerial perspective. The strongest, darkest colors are in the foreground, where you can still see *some* contrast between light and shadow, particularly in the trees and bushes. The more distant slope at the left is distinctly lighter and cooler, with almost no suggestion of contrast between light and shadow. And the distant peak is much paler and cooler, just as it was on the sunny day. The sky is no longer colorful, but it's still darker directly overhead, gradually growing paler toward the horizon. This study of an overcast day is also painted on a sheet of cold-pressed watercolor paper, and it's painted with the same mixtures as the study of the sunny day. The lighter tones of the slopes and trees contain less cadmium yellow and white, of course, while they contain more phthalocyanine blue and burnt sienna. The patches of shadow beneath the trees on the slope and beneath the bushes along the shoreline are *mainly* blue and burnt sienna, with just the slightest hint of yellow. It's worth noting that the stream in both paintings is painted with transparent color, diluted with pure water, to capture the transparency of the subject.

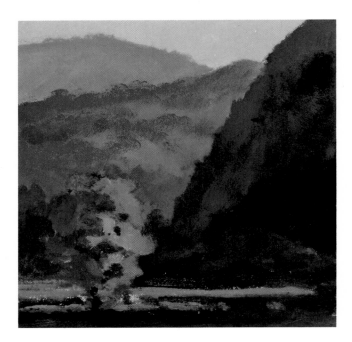

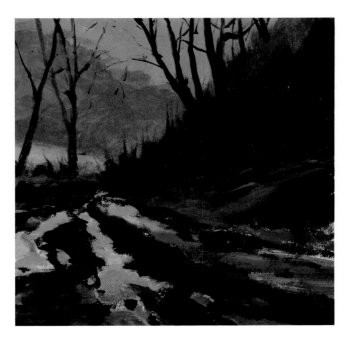

Cool Picture, Warm Notes. A simple way to create cool, harmonious color is to work with analogous colors like these blues, violets, and greens. (They're analogous because they all contain some blue.) And for a note of contrast in a picture that might look too cool, you can reach across the color wheel for the warm complement of one of these cool tones, like the color of the sunlit tree.

Warm Picture, Cool Notes. You can reverse this strategy by working mainly with warm, analogous colors like yellows, oranges, and coppery browns. And for contrast, you can find the cool complement of one of those warm mixtures on the opposite side of the color wheel. Here, the warmth of the landscape is enhanced by those few patches of cool color in the foreground.

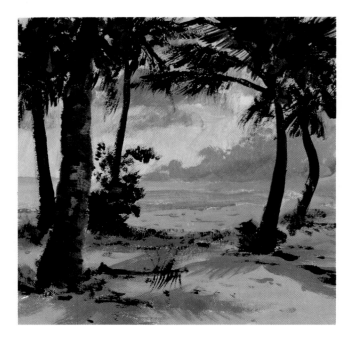

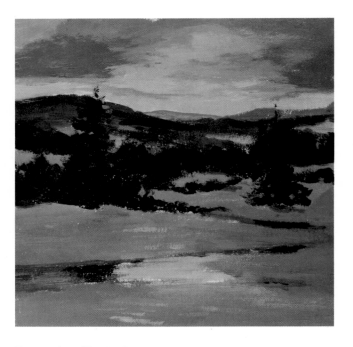

Repeating Colors. Another way to achieve color harmony is to interweave one particular color through all the others. This tropical landscape is unified by the repetition of a similar color in the clouds, on the distant shoreline, and in the shadows on the foreground. The cool shadows on the sand accentuate the warmth of the sunny areas of the beach.

Repeating Neutrals. Another way to unify a picture is to interweave neutrals through the other colors. In this winter landscape, the dark neutrals of the sky are repeated in the snow on the ground. The neutrals also surround and accentuate the brilliant colors that appear along the lower edge of the sky and then reappear as reflections in the land.

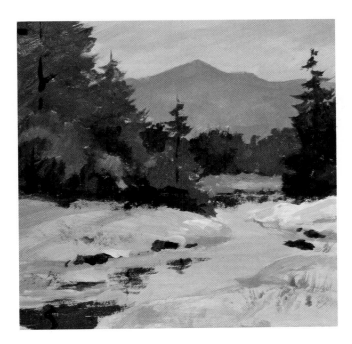

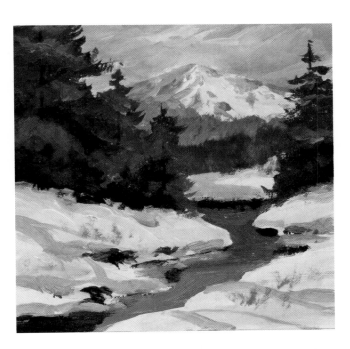

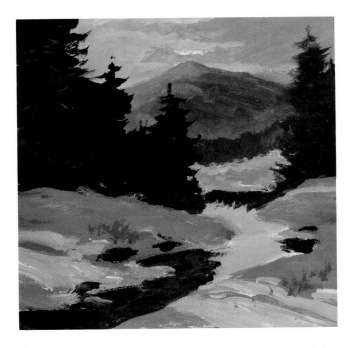

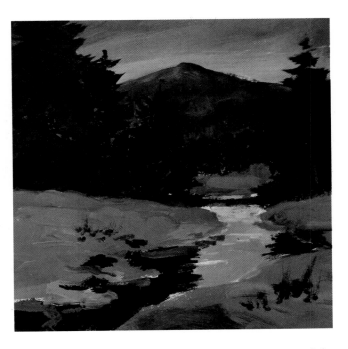

Early Morning. It's fascinating to paint the same subject at different times of the day, recording how the color changes from hour to hour. In the early morning, this snowy landscape is filled with warm, delicate color. The warm sky is reflected in the snow and water. The distant mountain, seen through the morning haze, is a flat, warm shape with no detail.

Midday. A few hours later, bathed in full sunlight, colors are stronger and contrasts more definite. The tones of the trees are deeper and more intense. There are stronger shadows on the snow, while the deep tone of the water reflects the sky color. The morning haze is gone, so you can see the details of the mountain, with its contrasts of sunlight and shadow.

Late Afternoon. As the sun begins to drop toward the horizon, the sky turns warmer, and this warm light is reflected in the stream. The sun throws a reddish light on the mountain. The trees, silhouetted against the sun, are dark shapes that cast deep shadows on the snow and somber reflections in the water.

Night. At nightfall, colors are stronger than you might expect. The moonlight in the sky reappears in the water. The snow still reflects light and is full of subdued color. There's just enough light to see some color in the dark trees. When the moon rises higher, the sky, mountains, and trees will contain rich, dark colors.

Step 1. These two rich colors—phthalocyanine blue and burnt sienna (plus white)—will give you a surprising range of warm and cool mixtures, and a full range of values. When you paint with this kind of limited palette, you're forced to create a *tonal* picture that depends heavily on accurate observation of values. The artist begins by making a pencil drawing on a sheet of illustration board. Then he blocks in the sky with a mixture that's mainly phthalocyanine blue and white, softened with a bit of burnt sienna. Toward the horizon, the artist adds more white to his strokes. He quickly blends the strokes of the sky into one another before the color dries.

Step 2. When the sky is dry, he paints the palest, most distant mountain with the same mixture that appears in the sky, with less white. He paints the darker, slightly warmer mountain at the left, with a mixture that contains less white and more burnt sienna—adding an extra touch of burnt sienna for the darker foliage at the top. Obeying the "laws" of aerial perspective, the nearer mountain at the right is distinctly darker, mainly blue and burnt sienna, with very little white. The artist adds less water when he paints the two darker mountains, so the color is less fluid and the strokes look rougher.

Step 3. Moving farther toward the foregound, the artist paints the darker, warmer cliff at the left with a mixture that contains more burnt sienna and less white than any of the earlier mixtures, although it still contains plenty of blue. The low triangle of land at the center of the picture is darker and cooler, so the artist adds more blue to this last mixture. When he paints the low strip of land in the lower left, the artist indicates the dark lines of the trees with the same cool, dark mixture he's used for the small triangle above. But then he adds more burnt sienna and white for the lighter patches.

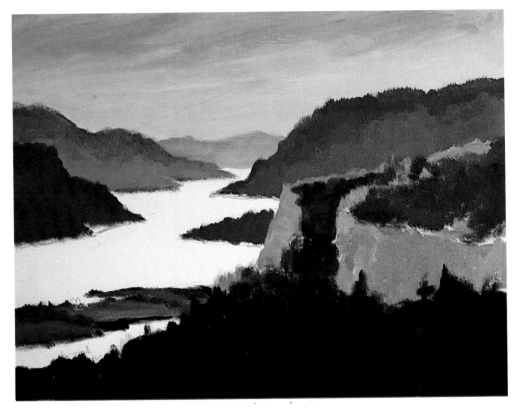

Step 4. The warm, sunlit sides of the cliffs in the foreground are covered with strokes of burnt sienna and white, cooled with a very small amount of blue. The dark, warm foliage along the tops of the cliffs is mainly burnt sienna, subdued by blue and lightened with just a touch of white. This same mixture, containing almost no white, is used to block in the warm, shadowy mass of trees in the foreground. By the end of Step 4, the landscape clearly obeys the "laws" of aerial perspective: the warmest, darkest tones—and the strongest contrasts of light and shadow—are in the foreground, while the colors grow cooler and paler in the distance.

Step 5. The water is painted with a series of straight horizontal strokes. To express the movement of the water and the shimmer of the light on its surface, the artist avoids blending the strokes smoothly into one another, but allows each stroke to retain the imprint of the brush. The darker strokes obviously contain lots of blue, just the slightest hint of burnt sienna, and a moderate amount of white. The artist lightens his strokes with more white as he follows the stream into the distance, where it catches the sunlight. He adds very little water to the paler strokes, so that the thick, rough texture of the white will accentuate the sparkle of the light.

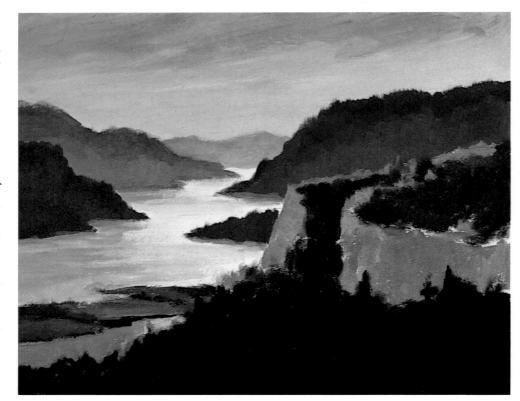

Step 6. The artist begins to develop the foliage along the tops of the cliffs and in the immediate foreground with small, rough strokes. These strokes are varied mixtures of all three tube colors, with more blue in the cooler strokes and more burnt sienna in the warmer strokes. He adds just a little water to these mixtures so that the paint will be thick enough to produce rough, irregular strokes. He applies the color with short, scrubby movements of a stiff bristle brush. The strokes have a ragged quality, like the foliage. He begins to suggest the craggy texture of the cliffs with similar rough strokes.

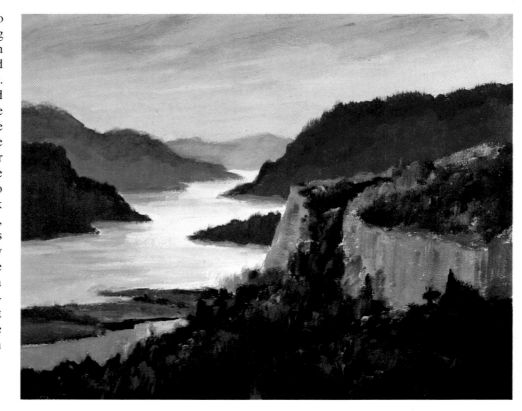

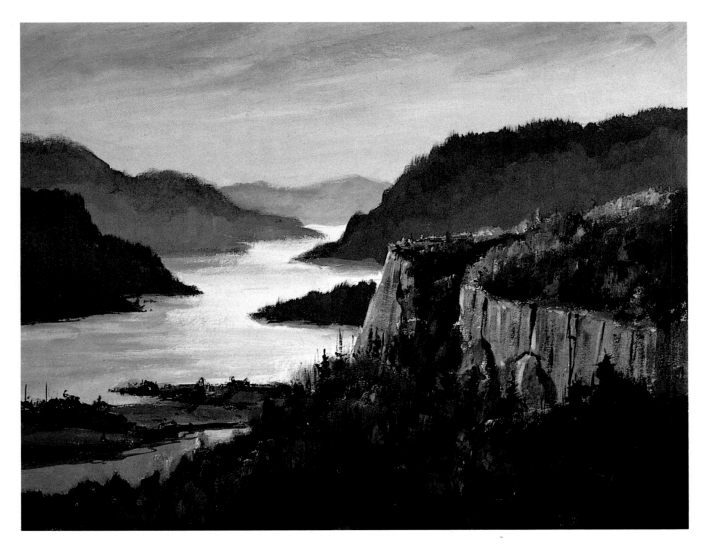

Step 7. To render the detail of the cliffs and foliage in the foreground, the artist switches to a small, round, soft-hair brush. Slender strokes of dark color suggest trunks and branches among the trees, and deep cracks in the sides of the cliff. These very dark strokes are phthalocyanine blue and burnt sienna, without white, but diluted with lots of water to produce a liquid paint consistency that lends itself to precise strokes. For the touches of light on the sides of the rocky cliffs, the artist rinses this small brush and dips it in white that's tinted with the slightest amount of blue and burnt sienna, again diluted with plenty of water for exact brushwork. In the lower left, the artist adds a few more dark strokes to suggest detail among the trees on the low strip of land. He also adds some shadow lines at the near edge of the shoreline. In the finished picture, the colors are subdued, but they're full of warm and cool variations. The values have been carefully observed and accurately recorded to create realistic light, atmosphere, and space in the landscape. To strengthen your command of values, try other tonal palettes, such as phthalocyanine blue and burnt umber, ultramarine blue and burnt umber or burnt sienna, or phthalocyanine green with burnt umber or burnt sienna. When you work with opaque color, you'll add white to lighten your mixtures. But you may also want to try working in a transparent watercolor technique, lightening and diluting your colors with pure water. (For the transparent technique, switch from illustration board to watercolor paper.)

Step 1. Now, to learn the basics of color mixing, you'll use just the three primary colors—blue, red, yellow, plus white—to discover how many different mixtures you can make with just these four tubes! This demonstration is painted with ultramarine blue, cadmium red light, cadmium yellow light, and titanium white on a canvas board. As usual, the artist starts with a pencil drawing. Then he paints the cool sky at the top with blue, plus a drop of red and white. He adds more white to this mixture for the lighted areas of the clouds. For their shadowy undersides, he adds a touch of yellow to the sky mixture to produce a warm neutral that he lightens with white.

Step 2. The artist carries the shadowy tone of the clouds across the lagoon, since water normally reflects the sky colors. When this pale tone is dry, he mixes a darker tone with lots of blue, a hint of red and yellow, plus white. He picks up a small amount of this color on a big bristle brush, which he holds at an angle and passes *lightly* back-and-forth over the rough surface of the canvas. The weave of the canvas breaks up the strokes to produce an effect that's called *drybrush*. The ragged drybrush strokes produce an irregular gradation from dark to light, suggesting the shimmering play of light on the lagoon.

Step 3. The primaries tend to subdue one another when they're all in the same mixture. For the dark, soft tone of the wooded headland, the artist blends blue, yellow, and white to create a rich, subdued green—and then he adds a hint of red to make it more neutral. Along the top of the headland, drybrush strokes suggest the ragged texture of the foliage. The darker shapes of the trees along the bottom of the slope are mainly blue and red, with a hint of yellow. The warm sand is blocked in with red, yellow, and white, softened with a speck of blue. A few touches of this warm mixture appear on the wooded slope.

Step 4. When the colors of Step 3 are completely dry, the artist paints the rich, warm, dark shapes of the leaning trunks with red and blue. In the warm areas, red dominates the mixture, while the darker markings on the trunks are dominated by blue. With a round, soft-hair brush, the artist paints the hanging foliage with blue and yellow, muted with a slight hint of red. The paler leaves at the right are modified with white, while the darker leaves at the top contain no white at all.

Step 5. Switching to a smaller, round brush, the artist paints the foreground foliage with a dense network of little strokes. He works with thick yellow and blue, diluted with some acrylic painting medium to produce a rich, buttery texture. He mixes the colors not on his palette, but directly on the canvas board, painting blue strokes over yellow and yellow strokes over blue to create a lively, irregular tone. Mixed on the canvas board in this way, the colors suggest variations of sunlight and shadow.

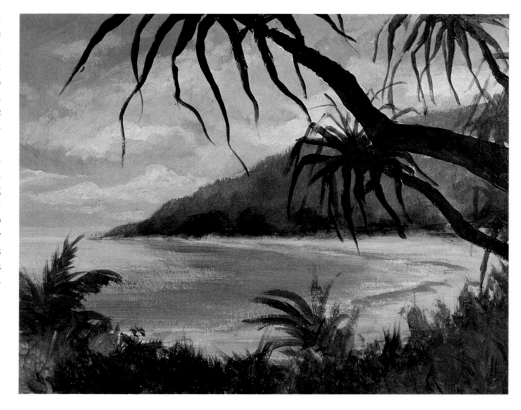

Step 6. The artist continues to develop the foreground foliage by overlapping strokes of yellow and blue. He works with small strokes, sometimes letting the yellow break through to suggest sunshine and sometimes letting the dark strokes suggest shadows. Then he adds more foliage to the palms with warm strokes that are mainly red and yellow, slightly subdued with a speck of blue. He uses the same warm tone to build up the detail of the trunks, lightening some of the strokes with white. Now there are lights and shadows on the trunks and in the hanging foliage.

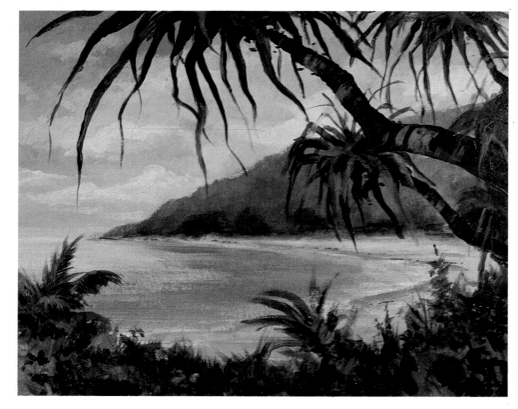

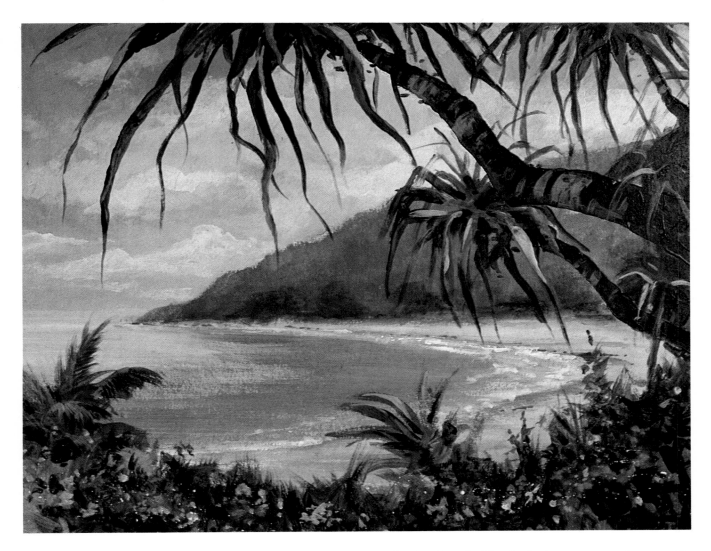

Step 7. Blending blue, yellow, and lots of white on the palette, the artist adds more pale, sunlit leaves to the clusters of foliage that dangle from the trunks of the palms. He adds a few strokes of the same pale mixture to the tangled foliage in the foreground to suggest sunlit leaves. Then, with the very tip of a round brush, he adds tiny touches of this color throughout the foreground foliage—plus touches of red and yellow, sometimes pure, and sometimes tinted with white. Now the foreground foliage is filled with tropical wildflowers, produced by the spatter technique. To make the wildflowers, the artist picks up very liquid color on a soft-hair brush, holds one hand a few inches above the painting surface, then smacks the handle of the brush against his outstretched hand. Droplets of liquid color spatter across the picture. The artist completes the picture by sharpening the edge of the beach with slender strokes that suggest foam. These strokes are almost pure white, faintly tinted with blue, and diluted with water to a fluid consistency for precise brushwork. The final picture proves the versatility of a palette that consists of just three primaries, plus white. Not only do you see a variety of subtle color mixtures, but you also see strong darks that are produced by mixing bright colors, without the aid of black. It's worthwhile to spend more time painting several pictures with different groups of primaries. The most brilliant combination would be cadmium red light and cadmium yellow light again, but with the dazzling phthalocyanine blue instead of the more subdued ultramarine blue. Another interesting combination would be phthalocyanine blue, cadmium yellow light, and naphthol crimson. Many artists enjoy painting with a subdued primary palette that consists of ultramarine blue, yellow ochre, and burnt sienna. By painting a series of pictures with different primary palettes, you'll develop an intimate knowledge of the behavior of the most important colors that are on your palette.

Step 1. When you paint with the full range of bright colors on your palette, you're *not* obligated to paint a brilliantly colored picture. On the contrary it's good experience to paint a *subdued* picture with these brilliant hues and force yourself to make subtle mixtures. In this demonstration, the artist paints a somber winter landscape with a full palette. He begins with a brush drawing on canvas in phthalocyanine blue, naphthol crimson, and white. Then he blocks in the sky with ultramarine blue, naphthol crimson, yellow ochre, and white—blending in more white as he moves toward the right.

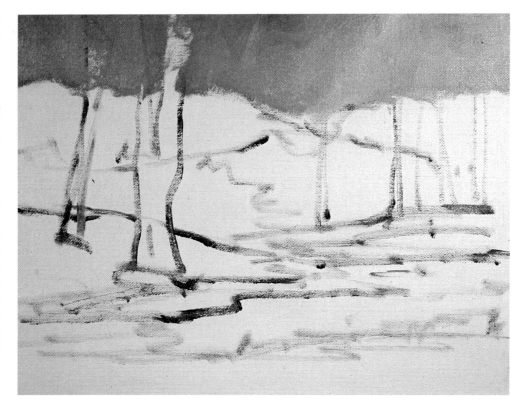

Step 2. The artist scrubs in the rough, dark bands of distant trees with short, vertical strokes of ultramarine blue, naphthol crimson, burnt umber, and white—adding more white for the paler trees on the snowy slope at the right. Tinting a batch of white with this mixture, he blocks in the snow between the dark rows of distant trees. Then he carries the mixture down the snowy slope at the center of the picture. Looking closely at the painting, you can see that the dark color of the trees has been drybrushed over the grain of the canvas to suggest the texture of the masses of distant foliage.

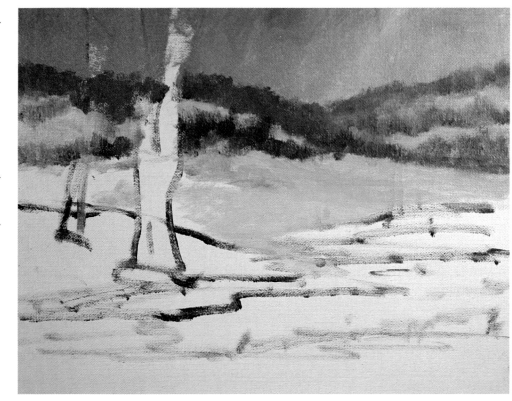

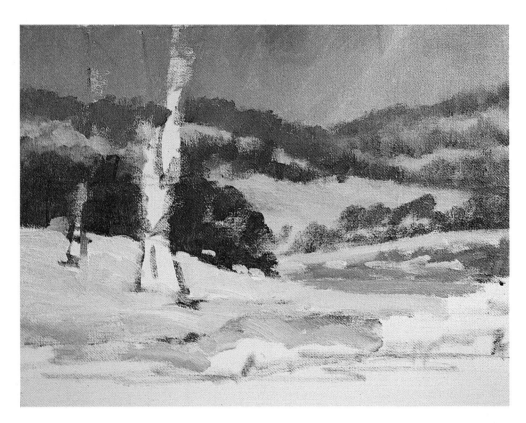

Step 3. The artist blocks in the dark tone of the thick foliage on the slope behind the two trees at the left. This tone is a mixture of phthalocyanine green, burnt sienna, and a touch of ultramarine blue. On the slope to the right, he blocks in the cooler foliage with phthalocyanine green and ultramarine blue, warmed with a speck of naphthol crimson and lightened with white. He blocks in the foreground snow with thick white, tinted with cerulean blue, cadmium orange, and burnt sienna. The shadows on the snow are burnt umber, yellow ochre, cerulean blue, and lots of white.

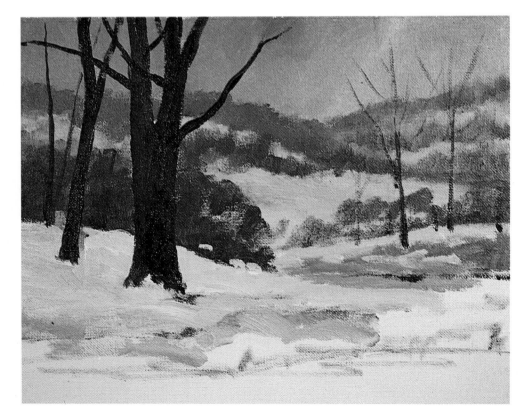

Step 4. The dark trunks and branches of the trees, with their subtle hints of color within the darkness, aren't black, but a mixture of phthalocyanine blue, burnt sienna, and a drop of naphthol crimson. The artist dilutes the mixture with liquid acrylic medium and a little water, so the consistency of the paint is creamy, but fluid enough for precise brushwork. For the dark trees at the left, the artist adds no white to this glowing, dark mixture. But to paint the slender, more remote trees at the right, he lightens the dark mixture with a little white. He paints the trees with a slender bristle brush.

Step 5. Blending phthalocyanine blue, naphthol crimson, and burnt umber, the artist uses a slim, rounded bristle brush, called a *filbert*, to drybrush masses of leaves over the trees in the upper right. He deposits such a thin film of color that the distant sky and landscape shine through the foliage. He brushes thick, ragged strokes of yellow ochre, burnt umber, and a hint of naphthol crimson, plus white over the foreground to suggest clumps of dead, frozen weeds in the snow. The thick color is softened with a drop of liquid medium, so the brush drags the dense mixture over the canvas, leaving ragged patches of color.

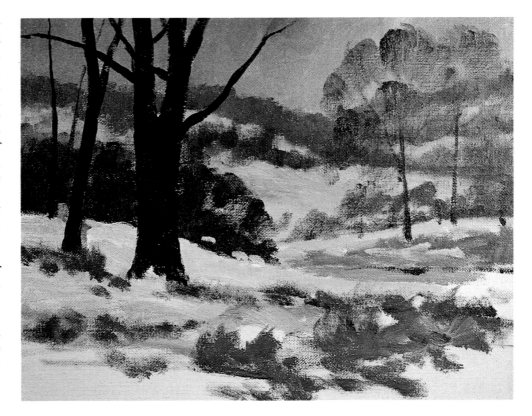

Step 6. The artist enriches the warm patches of color in the foreground with short, scrubby strokes of yellow ochre, burnt sienna, ultramarine blue, and white—and cooler mixtures of cerulean blue, burnt umber, yellow ochre, and white. These warm and cool strokes are blended into one another while the color is wet. The artist covers the remaining foreground with a snow mixture that's mainly thick titanium white, tinted with a drop of the cooler mixture that appears among the weeds. The thin, horizontal band of the stream at the right is cerulean blue, burnt umber, and white.

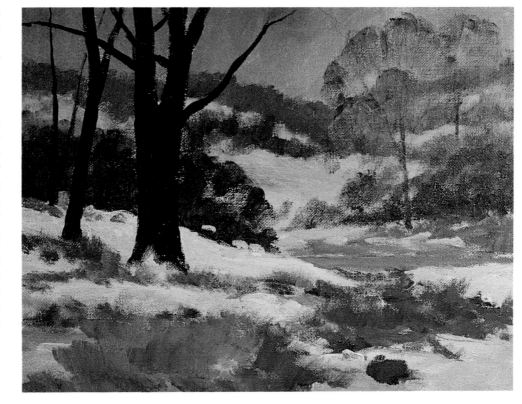

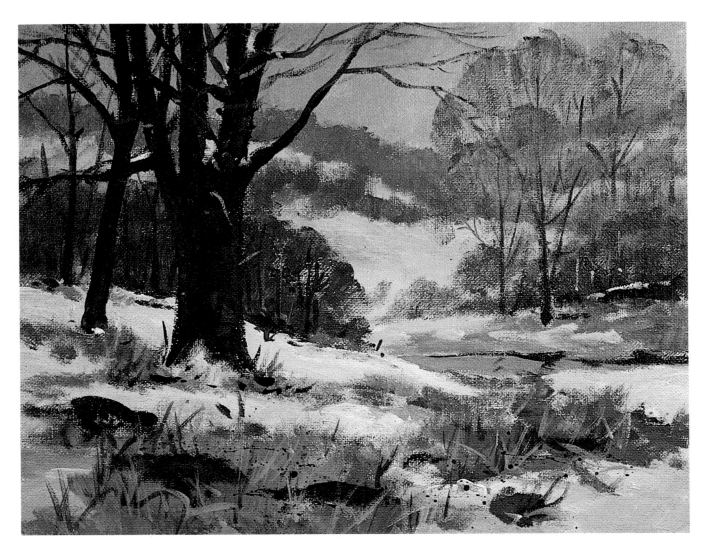

Step 7. The artist completes the picture by adding small strokes to suggest the details that convert the broad masses of color into a realistic landscape. He blends phthalocyanine blue, burnt sienna, and a little naphthol crimson on his palette, thinning this dense mixture with acrylic medium and water, to add more branches to the dark trees at the left. The dark trees need some strokes of warmer, lighter color, so he adds thick strokes of ivory black, burnt sienna, and yellow ochre. Now there's a subtle suggestion of light and shade on the dark trunks. Within the shadowy mass of foliage behind the dark trees, the artist adds thin strokes of ultramarine blue and burnt sienna to indicate trunks and branches. He adds a little more ultramarine blue, plus white, to this mixture to place additional branches on the pale trees at the right. A few strokes of this mixture appear in the stream to suggest the reflections of these trees. Among the weeds in the foreground, the artist adds several dark, flat rocks with ivory black, burnt umber, and yellow ochre. This same mixture is used to place dark weeds at the base of the big tree and to scatter other dark weeds across the foreground. The artist also adds paler weeds in the foreground with a blend of cadmium yellow light, burnt umber, a little cerulean blue, and white. Finally, he adds lots of water to the mixture of ivory black, burnt umber, and yellow ochre that remains on his palette—and then he spatters this liquid color across the foreground. Reviewing the variety of color mixtures in this subdued winter landscape, you'll find that the artist has used many of the most brilliant colors on his palette, as well as the more subdued colors. Thus the finished picture, is far from monochromatic, but is actually filled with color. These muted mixtures are colorful because they contain many of the brightest colors on the palette.

Step 1. Now the artist demonstrates how to use the bright colors on your palette to paint a sunny landscape. On a sheet of thick illustration board that he's coated with acrylic gesso, the artist draws the main shapes in pencil. He draws the surrounding rocks with special care, since these shapes define the outer edges of the stream. With a big bristle brush, he blocks in the cool tones of the upper sky with cerulean blue, yellow ochre, and white. He places warm shadows beneath the clouds with strokes of yellow ochre and white, plus a speck of cerulean blue. For the sunlit areas of the clouds, he uses *almost* pure white, tinted with the shadowy mixture.

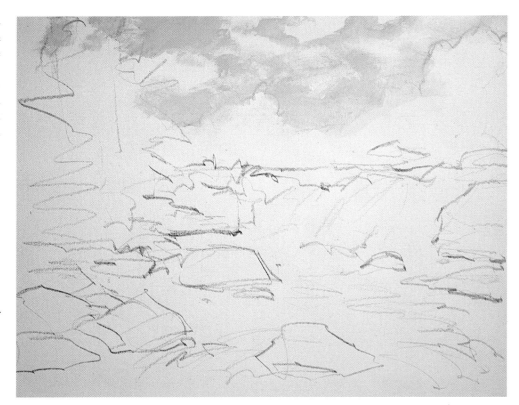

Step 2. The artist paints the deep tones of the trees at both sides of the painting with a thick mixture of phthalocyanine blue, burnt sienna, and yellow ochre, with just enough water to produce a pasty consistency. He then drags the bristle brush across the painting surface with ragged strokes that suggest the texture of the foliage. On the far shore, between the two masses of dark trees, the artist paints the pale trees with cadmium yellow light, cerulean blue, and lots of white—with a dark patch of cerulean blue, cadmium yellow light, burnt umber, and white to indicate the tone of the shadow beneath the trees.

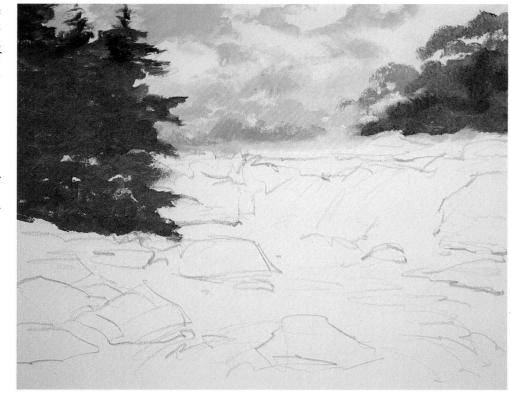

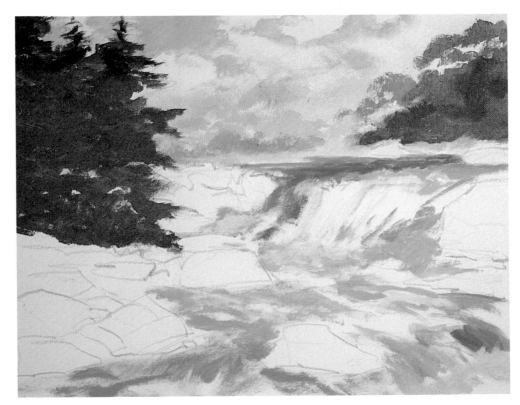

Step 3. With a slender bristle brush, the artist begins to paint the cool tones of the water with varied mixtures of ultramarine blue, cerulean blue, a little naphthol crimson, and white. The darkest blue strokes contain more ultramarine blue, the paler blue strokes contain more cerulean blue and white, and the warmer strokes contain more crimson. The colors are diluted with enough water to produce a thin, milky consistency and are scrubbed thinly over the illustration board to suggest the lively, foaming action of the water. Notice how the direction of the strokes follows the movement of the water.

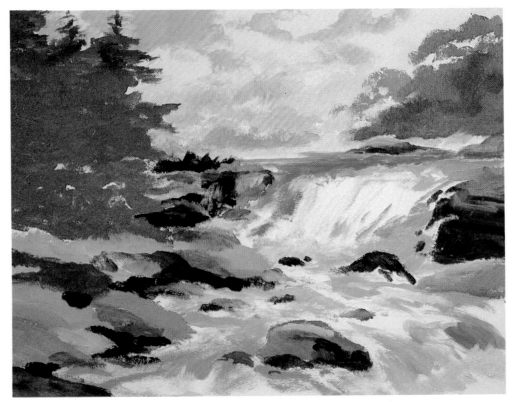

Step 4. Having preserved the pencil outlines of the rocks, the artist now blocks in their color. The sunlit tops of the rocks are mixtures of cadmium red light, cadmium yellow light, burnt sienna, and white. The warm shadows on the sides of the rocks are burnt sienna, cadmium red light, ultramarine blue, and white, with an occasional touch of yellow ochre. And the strong darks along the lower edges of the rocks are phthalocyanine blue, burnt sienna, and the slightest hint of cadmium red light. The paint is thinned with acrylic medium and water to a smooth, creamy consistency that lends itself to broad, solid strokes.

Step 5. Now the artist works on the water with strokes of white, blended with acrylic gel medium to produce thick strokes that will stand up slightly and retain the imprint of the brush. He tints the thick white with small amounts of cerulean blue and an occasional touch of ultramarine blue to vary the values of his strokes. Where the foam is most dense, the white is thickest and the brushstrokes are roughest. The strokes follow the movement of the water down the waterfall and over the rocks toward the lower right. The original blues still shine through.

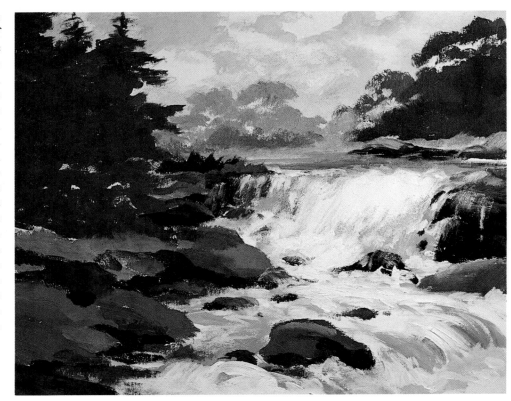

Step 6. Within the dark mass of foliage at the left, the artist adds deep shadows with phthalocyanine blue, burnt sienna, and a speck of cadmium red light. He dips a pointed, soft-hair brush into this mixture—adding a bit of white—to draw pale trunks and branches against the dark foliage on either side of the stream. Beneath the dark trees at the left, the artist places a shadow on the rocks by repainting the tops with phthalocyanine blue, yellow ochre, and burnt sienna. Beneath the far shore, the artist drybrushes a thick stroke of white, faintly tinted with cerulean blue, to suggest sunlight on the water.

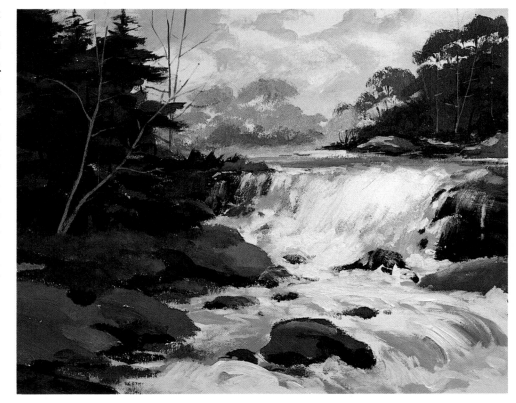

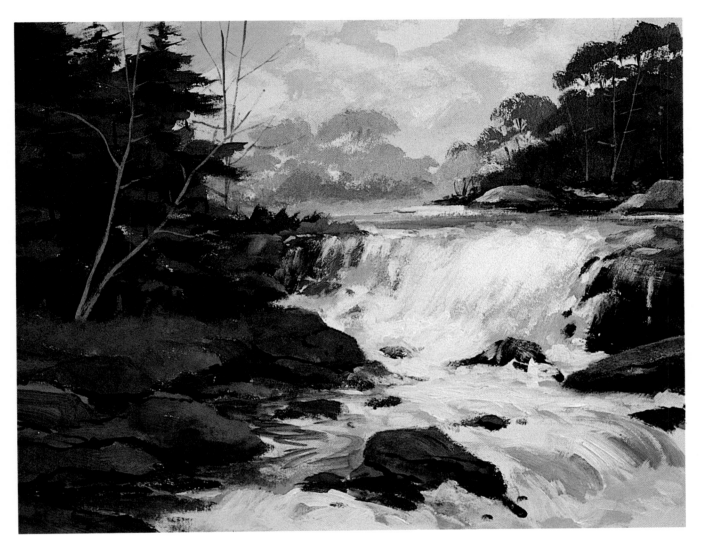

Step 7. In this final stage, the artist concentrates on the details of the rocks and the water in the foreground. With a sharply pointed soft-hair brush, he draws the dark divisions between the rocks and the cracks in the rocks themselves with precise strokes of phthalocyanine blue and burnt sienna, diluted with liquid painting medium and water to produce the right consistency for precise brushwork. Suddenly, the broad masses of color in Step 6 are transformed into realistic rocks. Beneath the warm shapes of the rocks, the artist places strokes of this dark mixture to reinforce the shadowy edges of the rocks in the water. In the foaming water beneath the rocky shore at the left, the artist places thin, swirling strokes of phthalocyanine blue, warmed with burnt sienna and lightened with a touch of white, to suggest the reflections of the trees, the erratic brushwork indicating that these

reflections are broken up by the movement of the stream. The artist brightens the foam in the foreground with carefully placed, thick strokes of white—faintly tinted with cerulean blue. As you review the seven steps in this demonstration, you'll see that the mixtures contain most of the bright *and* subdued colors on the palette. The completed painting is filled with color and with sunlight, but no garish mixtures leap off the painting surface. Each color stays in its place, as it does in the natural landscape. The sunlit water *looks* sunlit not because it was painted with brilliant colors, but because the bright tones of the water are surrounded by more subdued, shadowy colors. As you've already learned, colors look *brighter* when they're surrounded by subdued colors, and *lighter* when they're surrounded by dark colors.

Step 1. In the first four demonstrations, the artist mixed colors on his palette and applied them directly to the painting surface in a single operation. This method is called direct or *alla prima* painting. But you should also try other methods of painting for effects that are quite different from direct painting. This demonstration shows the simplest method, called *underpainting* and *overpainting*. After the usual pencil drawing on a gesso-coated illustration board, the artist blocks in the background with a warm neutral made with ultramarine blue, burnt umber, yellow ochre, and white. In the upper right, he lightens the mixture with more white.

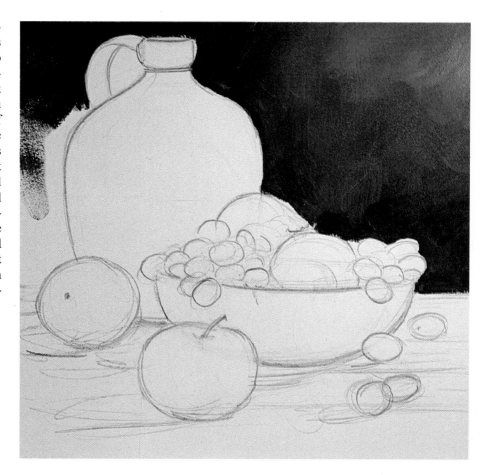

Step 2. All the artist has on his palette is a big mound of this dark mixture—ultramarine blue, burnt umber, and yellow ochre—which he modifies with different amounts of titanium white. Thus, he paints the lights, halftones, shadows, and reflected lights on the jug and fruit with this same basic mixture, and simply blends in more white as he needs it. As you can see, the entire still life is painted in the same warm monochrome that was used in the background of Step 1.

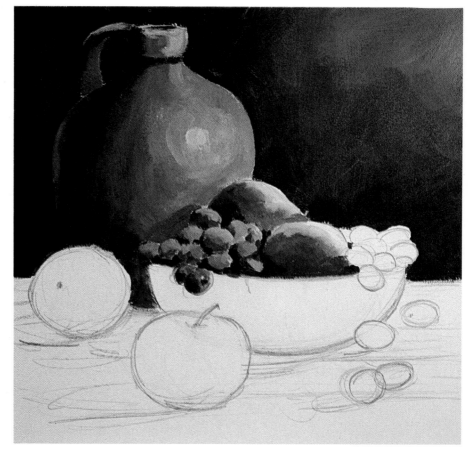

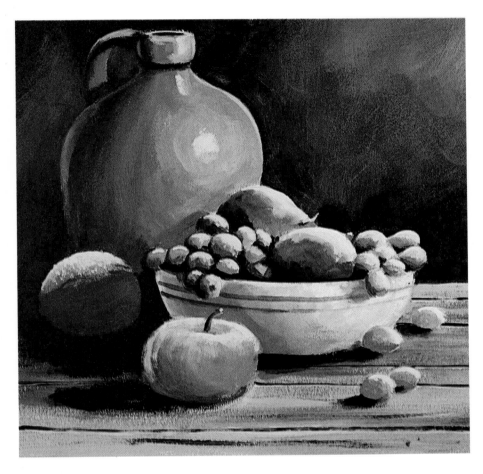

Step 3. As the artist works on the lower half of the picture, he adds much more white to the basic monochrome mixture to paint the brighter shapes of the fruit bowl, the table, and the fruit. When he paints the darkest details—the shadows on the table, the cracks between the wooden boards, and the texture of the wood—he adds no white to the mixture. Notice the interesting lighting effect on the shape of the orange at the extreme left. Most of the orange is in the shadow of the fruit bowl, while only the top of the sphere catches the light. The artist renders the lighted top with tiny dots of pale color that express the characteristic texture of the thick skin of the fruit.

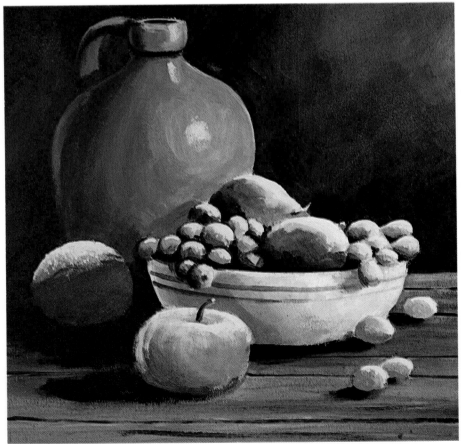

Step 4. By the end of Step 3, the artist has completed the entire picture in values, without color. This is a monochrome underpainting—the first phase of the painting process. When the underpainting is dry, he can begin the overpainting, working in transparent color that allows the values of the underpainting to shine through. He dilutes all his colors with liquid acrylic medium and water to produce fluid, transparent *glazes*. First he brushes a glaze of burnt sienna over the background. Then he glazes the large jug with burnt sienna and yellow ochre. The color of the wood emerges as he glazes the table with a warm mixture of burnt sienna and burnt umber.

Step 5. Blending cadmium red light with a little naphthol crimson on his palette, the artist adds liquid acrylic medium and water, and he glazes this bright mixture over the apple. On the smaller, oval forms of the grapes, he glazes a pale tone of cadmium yellow light. The colors are lightened with acrylic medium and water—not with white, which would reduce their transparency. Normally, a glaze should be as clear and transparent as a sheet of colored glass!

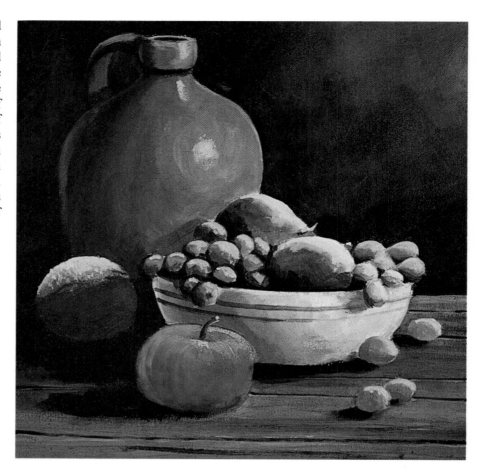

Step 6. When the cadmium yellow glaze on the grapes is dry, he glazes them again with a mixture of phthalocyanine green and cadmium yellow light, leaving the lighted tops of the grapes untouched. The softer tone of the pear is glazed with phthalocyanine green and yellow ochre. The warm tone of the apple in the bowl (like the one on the table) is a glaze of cadmium red light and naphthol crimson. A glaze of cadmium red light and cadmium yellow light is brushed over most of the orange, with just a bit more yellow at the very top. The artist brushes a delicate glaze of cerulean blue over the fruit bowl. And then he darkens the shadows around the fruit—both in the bowl and on the table—with transparent touches of ultramarine blue.

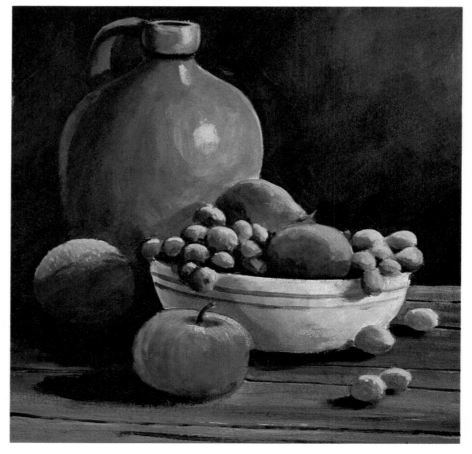

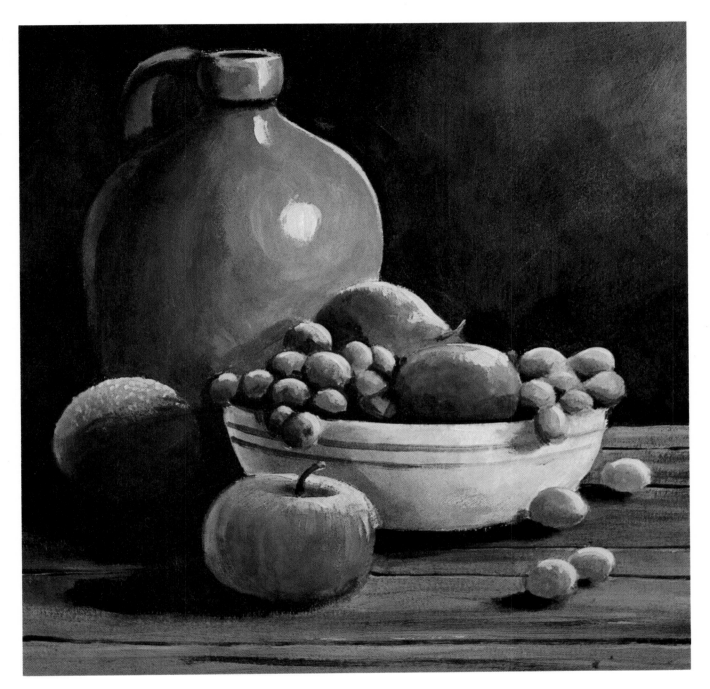

Step 7. In the final stage of the painting, the artist strengthens the lights in the still life with small touches of white, warmed with a hint of yellow ochre, and diluted with liquid acrylic painting medium. He brightens the highlights on the jug and then strengthens the lighted edge of the jug on the right-hand side. Moving a small brush deftly over the lighted tops of the various pieces of fruit, he adds a few touches of white to each shape—just enough to make these forms look more luminous and three-dimensional. Notice how the strokes of white curve down the sides of the apple. The brush merely touches the top of the orange with pinpoints of light to accentuate the shining texture of the skin. As you can see, a painting executed in transparent glazes on a monochrome under-painting has a very different character from a direct (or *alla prima*) painting that's done in opaque color. The monochrome underpainting gives the picture a much stronger feeling of light and shade traveling over three-dimensional forms. And the glazes have a glow—a feeling of inner light—that's possible only with transparent color. This technique is also a practical solution when you're painting a subject that has complicated forms and an intricate play of light and shadow. You can solve the problems of form and light and shade in the monochromatic underpainting, without dealing with the problems of color. Then you can concentrate entirely on color when you get to the overpainting.

Step 1. Now experiment with underpainting in color. The purpose of this technique is not to render light and shade in the underpainting, but to provide undertones that will produce interesting optical mixtures with the overpainting. The artist draws a desert landscape in pencil on a sheet of canvas-textured paper. Then he underpaints the sky with a thin layer of naphthol crimson, titanium white, and plenty of water. He leaves the painting surface bare to indicate the lighted areas of the clouds. Although the sky will be overpainted in cool colors, this warm, contrasting underpainting will add depth and richness to the cool tones of the sky and clouds.

Step 2. Unlike the underpainting of the sky—which will *contrast* with the overpainting—the land is underpainted with a warm tone that will *harmonize* with the overpainting. This underpainting is a thin, washy tone of yellow ochre and white. Then he underpaints the rocky shapes on the horizon with a cool tone—ultramarine blue and white—that will enrich the warm overpainting. The completed underpainting is applied in thin layers of color—with lots of water—to retain the canvas texture, which will enliven the brushwork of the overpainting.

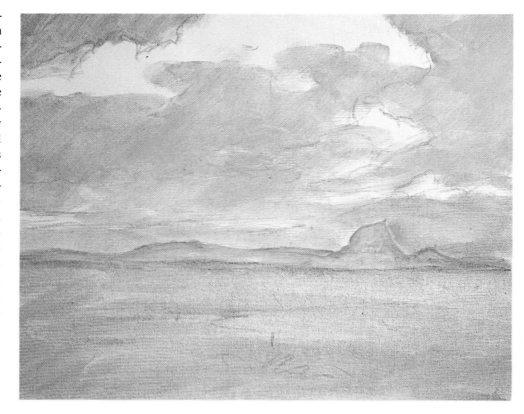

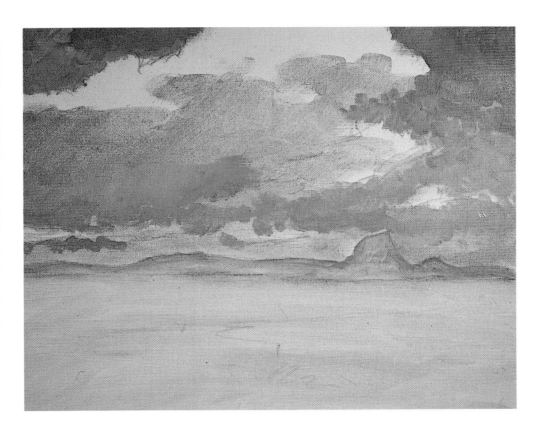

Step 3. The artist blends ultramarine blue, cerulean blue, a little yellow ochre, and white on his palette. From this point on, he dilutes his mixtures with liquid painting medium and water. He begins to overpaint the sky with variations of this mixture, adding more ultramarine at the top and more white toward the horizon. He moves his brush with a back-and-forth scrubbing motion—called *scumbling*. Scumbling deposits the color in a thin, semi-opaque layer that allows the warm tone of the underpainting to shine through. He also leaves occasional gaps in the underpainting. You can see such gaps in the upper left-hand corner and at the right.

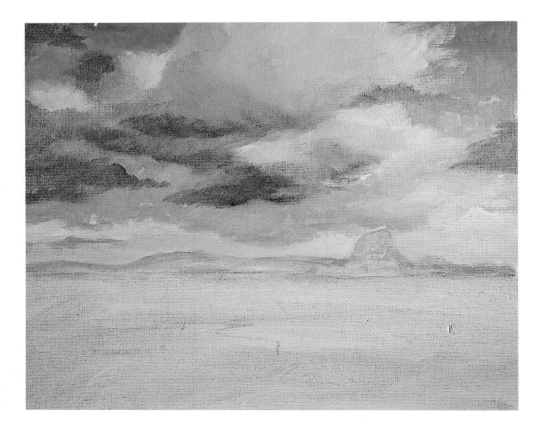

Step 4. The artist darkens the shadowy undersides of the clouds with a warm mixture of burnt sienna, ultramarine blue, and a touch of cadmium red light, plus white. Then he adds a little more ultramarine blue and lots of white to this mixture to paint the paler tones of the clouds—varying the amount of white so that some clouds are lighter and others are darker. Adding yellow ochre and white to the pale cloud mixture, he brushes a warm tone along the horizon, beneath the clouds. The entire sky is painted with scumbling strokes that spread the paint so thinly that the underpainting shines through, adding a subtle hint of warmth.

Step 5. Over the cool underpainting of the distant mesas at the horizon, the artist glazes cadmium red light, cadmium yellow light, and burnt umber. The tall, dark rock formation is overpainted with thick strokes of phthalocyanine blue, burnt sienna, and yellow ochre, with more blue on the dark side. These thick strokes are semitransparent because the color is blended with acrylic gel medium. The foreground is first glazed with cool mixtures of ultramarine blue, cadmium yellow light and yellow ochre, followed by warm scumbles of cadmium red light, cadmium yellow light, and burnt umber in various proportions, so some strokes are warmer and others are cooler. The ragged strokes, broken up by the painting surface, suggest coarse desert plants.

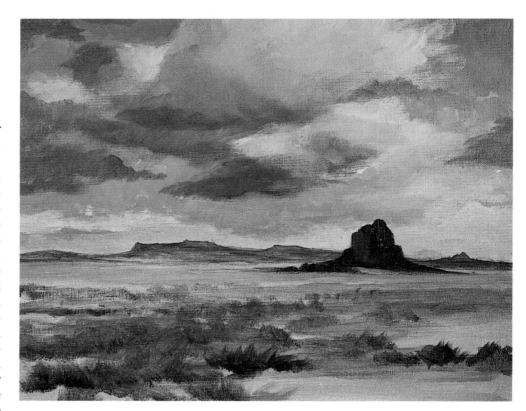

Step 6. The artist scumbles the lighter, brighter areas of the clouds with titanium white that's tinted with cerulean blue, yellow ochre, and a drop of naphthol crimson. He scumbles phthalocyanine blue, burnt umber, and white on the shadowy undersides of the clouds. Then he builds up the cool tones of the sky with phthalocyanine blue, a little burnt umber and yellow ochre, plus white. He draws a few streaks of this mixture across the lower sky, near the horizon. And he brightens the horizon with white, tinted with yellow ochre. All these strokes are thin scumbles. The underlying warm tones show through and create optical mixtures with the overpainting.

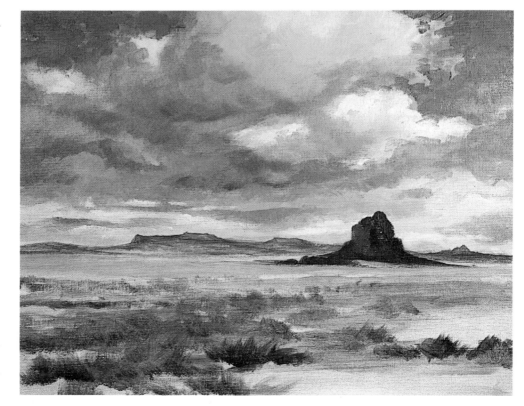

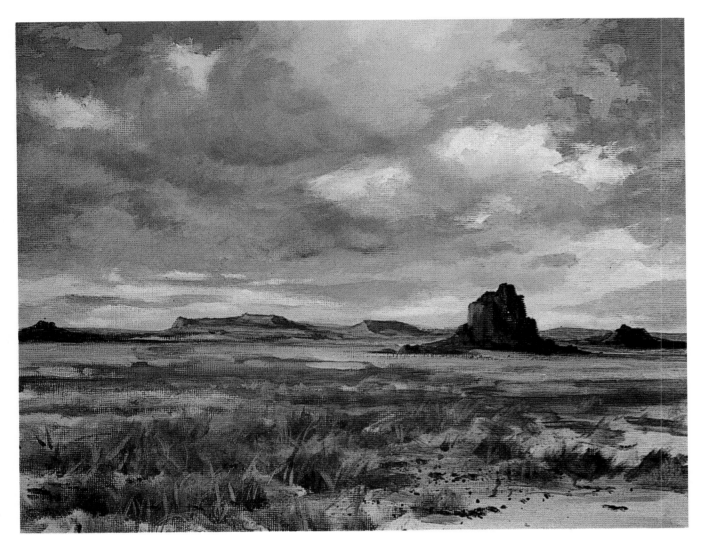

Step 7. At the extreme right and left of the horizon, the artist adds dark rock formations with liquid, transparent glazes of cadmium orange, burnt sienna, and phthalocyanine blue. He uses the same dark glaze to add detail to the tall rock formation. Then he lightens his glaze with water to add shadows and dark edges to the low mesas along the central horizon. Across the flat landscape just beneath the horizon, the artist glazes a warm, shadowy mixture of ultramarine blue and alizarin crimson. He carries a few strokes of this warm tone into the foreground. The coarse desert growth in the foreground becomes more realistic as the artist adds scrubby, transparent vertical and diagonal strokes of ultramarine blue and cadmium yellow light for the shadowy patches, cadmium orange and burnt sienna in the brighter areas to the left, and burnt sienna and phthalocyanine green for the warm neutrals. When these glazes dry, the artist goes over them with slender strokes of yellow ochre and white to suggest individual plants caught in the sunlight. The artist adds water to some of the darker mixtures on the palette and spatters droplets across the foreground to suggest a few stones. Finally, the artist brightens the bare desert just below the horizon with horizontal strokes of yellow ochre and white, darkened with a speck of burnt umber. In this landscape, the underpainting is very simple—just three colors applied thinly over most of the painting surface. At first glance, the underpainting seems to disappear beneath the overpainting, but those undertones are still there. Because the overpainting consists almost entirely of thin scumbles and transparent glazes, virtually every color in the finished painting is an optical mixture that's strongly influenced by the underpainting. Study the sky, for example, where the warm underpainting creeps through, lending depth and subtlety to the cooler colors of the overpainting. In the same way, the cool underpainting of the rocky shapes adds depth and complexity to the warm overpainting. And the analogous underpainting tone of the land adds unity to the complex colors of the overpainting. As you can see, the color of the underpainting may *contrast* or *harmonize* with the overpainting. You should experiment with underpaintings that work both ways.

Step 1. After learning how to work with a limited-color underpainting, now see how to use a full-color underpainting. The artist makes a careful pencil drawing on a sheet of watercolor board—cold-pressed watercolor paper that's mounted on stiff cardboard. He defines each shape so he has a clear idea of where each underpainting tone will go. At the left, he underpaints the trees with a bright mixture of cadmium orange and cadmium red light, adding more red for the hot tone of the shore beneath the trees. The sunny foreground tone is scrubbed in with strokes of cadmium yellow light and yellow ochre. The underpainting mixtures are diluted with water.

Step 2. A wash of yellow ochre and a hint of burnt sienna is brushed over the sky, leaving bare paper for the clouds. Cadmium yellow light is added to this mixture to underpaint the small patches of foliage along the top of the painting. The dark foliage, seen through the tree trunks at the right, is underpainted with phthalocyanine green and a little burnt sienna. The mountain is underpainted with naphthol crimson and ultramarine blue. The same mixture, with more ultramarine, is brushed over the shadowy area of the stream. Still more ultramarine is added to the mixture for the shadows on the tree trunks. The underpainting is complete.

Step 3. The artist glazes a cool mixture of cerulean blue, ultramarine blue, and white, diluted with water, over the warm sky. He adds even more water as he nears the horizon, where the sky is warmer. He leaves bare paper for the lighted edges of the clouds. Over the warm underpainting of the mountain, the artist scumbles ultramarine blue, naphthol crimson, and white. Cadmium orange, cadmium yellow, and burnt sienna are blended on the palette. Then he scumbles this warm, dark tone over the cool underpainting of the dark foliage at the right. The resulting optical mixture is a particularly fascinating interplay of warm and cool tones.

Step 4. A cool glaze of phthalocyanine green, with a little ultramarine blue, is brushed over the warm underpainting of the foliage at the left to produce another fascinating warm-cool optical mixture. The artist adds a bit of burnt sienna to this cool glaze and carries it down over the shoreline at the left. He warms the opposite shoreline on the right with strokes of this mixture. With rough, irregular strokes, he carries a cool grassy tone over the sunny underpainting of the foreground. This cool glaze is a mixture of phthalocyanine green, ultramarine blue, and a little burnt sienna, diluted with plenty of water so that the bright underpainting shines through.

Step 5. The tree trunks are scumbled with burnt sienna, ultramarine blue, yellow ochre, and white—with more burnt sienna and ultramarine in the shadows. The shadowy reflections in the water are a dark mixture of burnt sienna, phthalocyanine green, and a little ultramarine. At the top of the picture, the sunny underpainting of the foliage is glazed with cadmium yellow light and cadmium red light. At this stage, the artist is beginning to work with slightly thicker color, so the glazes are diluted with liquid painting medium and a bit of water—rather than the pure water he's used in the first four steps.

Step 6. The artist adds trunks, branches, and touches of shadow to the distant foliage with a dark, transparent mixture of phthalocyanine blue and burnt sienna. He also uses this tone to sharpen the edges of the shoreline. Then he scumbles a pale tone of cerulean blue and white over the water, drybrushes ultramarine blue and burnt sienna over the shadow areas of the trunks, and builds up the lights with drybrush strokes of yellow ochre and white. The same mixture of yellow ochre and white reappears in the slender strokes that suggest sunstruck branches on the foreground trees and sunstruck leaves on the distant foliage.

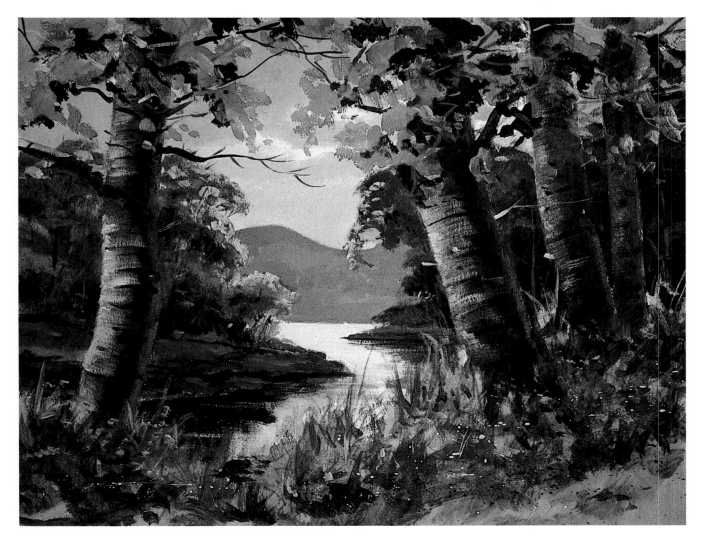

Step 7. Dark touches of shadow and more branches are added to the sunny foliage at the top of the picture with strokes of phthalocyanine blue and burnt sienna. Then the artist concentrates on the texture and detail of the foreground. The dark strokes among the tangled grass are made with glazes of ultramarine blue and cadmium yellow light, with an occasional touch of burnt sienna, diluted with plenty of acrylic medium so that the color remains transparent and allows the sunny underpainting to shine through. The artist uses two different brushes for the foreground: a small bristle brush for the thicker, more irregular scrubs of color, and a slender, soft-hair brush for the individual blades of grass. The bright grass—caught in the sunlight and silhouetted against the dark background—is painted with cadmium yellow light and white, plus a drop of ultramarine blue. A few touches of bright sunlight are added to the foreground leaves with carefully placed strokes of cadmium yellow light and cadmium orange. Now compare the completed picture with the underpainting to see how these optical mixtures work. Notice how the warm undertone of the sky and the distant trees shines through the cool overpainting. The warm underpainting of the foreground also creates the feeling of sunlight among the cooler strokes of the overpainting. Especially obvious is the way the warm underpainting of the foreground foliage reinforces the warm overpainting. It's only in the tree trunks that the underpainting seems to disappear. But even there the cool shadows of the underpainting still influence the gradation of light and shade in the final picture.

Step 1. Acrylic is particularly effective for a kind of underpainting that depends upon texture, rather than on color. Acrylic modeling paste—a ready-made mix of acrylic medium and marble dust—can be blended with color or used alone to create a rough textured surface that's wonderful for painting subjects like these rocks and driftwood. The artist begins with a pencil drawing on canvas board. Then he spreads acrylic modeling paste on the rocks and driftwood with a palette knife, patting the paste on the rocks with the flat blade to build up their texture. On the driftwood, he applies the paste with long strokes that follow the direction of the trunk and suggest the texture of the dried, shrunken wood.

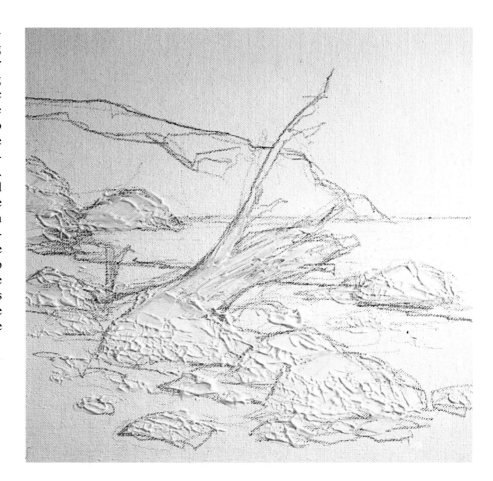

Step 2. The modeling paste is thick and needs plenty of time to dry, so the artist now concentrates on the sky. First he brushes yellow ochre and white over the entire sky area. While this warm tone is still moist, he blends in the cooler sky tones with ultramarine blue, a little naphthol crimson, and white. Then he builds up the clouds with yellow ochre and white, plus an occasional touch of burnt sienna and ultramarine blue in the darker undersides of the clouds. He works very thinly because he wants the rough texture of the rocks and driftwood to stand out against the smooth texture of the rest of the painting.

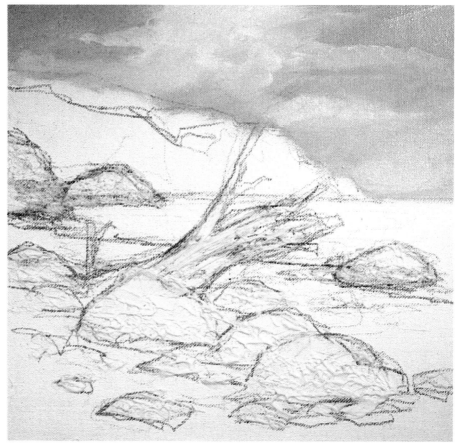

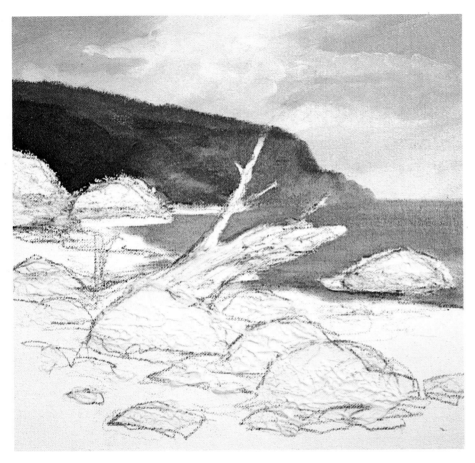

Step 3. The water is painted with smooth, horizontal strokes of ultramarine blue, yellow ochre, and white. The artist blocks in the dark side of the cliff with ultramarine blue, naphthol crimson, burnt sienna, and white, adding more burnt sienna in the darker areas. Along the top of the cliff, he indicates the somber tone of the foliage with ultramarine blue and yellow ochre. He drybrushes the color where the edge of the cliff meets the sky to suggest the rough texture of the coarse grass and bushes that grow along the shore.

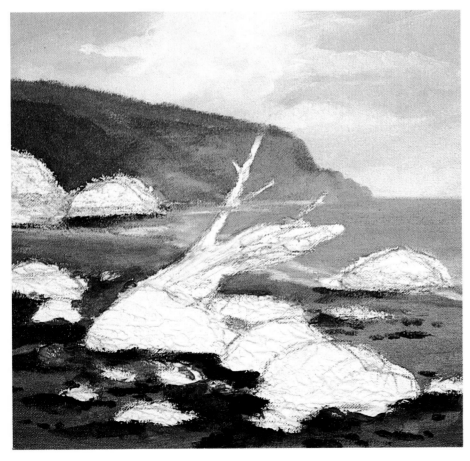

Step 4. A thin mixture of burnt sienna, yellow ochre, and white is brushed over the sand and carried carefully around the thick masses of modeling paste. The shadows of the rocks on the sand are added with burnt sienna and ultramarine blue. Around the rocks, the artist places small touches of this mixture to indicate scattered pebbles.

Step 5. The artist blends yellow ochre and titanium white with just a little burnt umber, and dilutes this with liquid medium. He brushes this pale, creamy mixture over the rocky shapes in the foreground. Then he drybrushes a darker mixture of burnt sienna, ultramarine blue, and liquid medium over the shadowy sides of the foreground rocks and over the dark mass of rocks at the left, just beneath the cliff. The ragged texture of the dried modeling paste breaks up these strokes to produce a coarse, granular texture. Now you begin to see why that rough underpainting is so important.

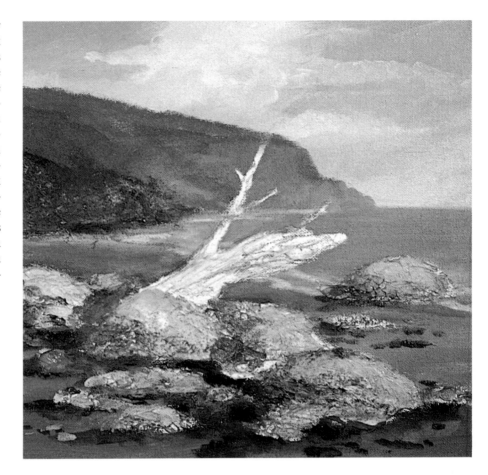

Step 6. Over the rocks, the artist continues to drybrush a thick, dark mixture of burnt sienna and ultramarine blue—diluted with liquid medium. The brush hits only the high points of the rough underpainting, and the texture becomes more obvious with each successive stroke. The deep shadows between the rocks are drybrushed with a darker mixture of ultramarine blue and burnt sienna. These strokes are also roughened by the underlying texture. This same color is used to reinforce the dark form of the distant rock formation at the left. Finally, the artist begins to indicate the shadows on the driftwood with a transparent glaze of this same mixture.

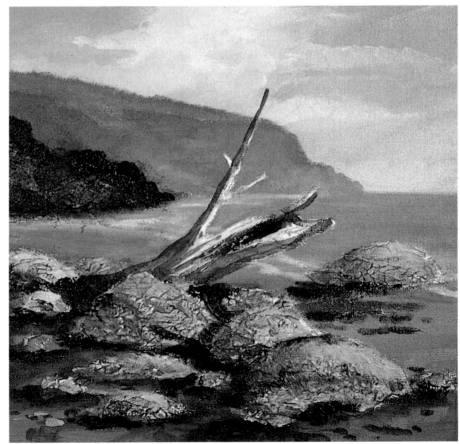

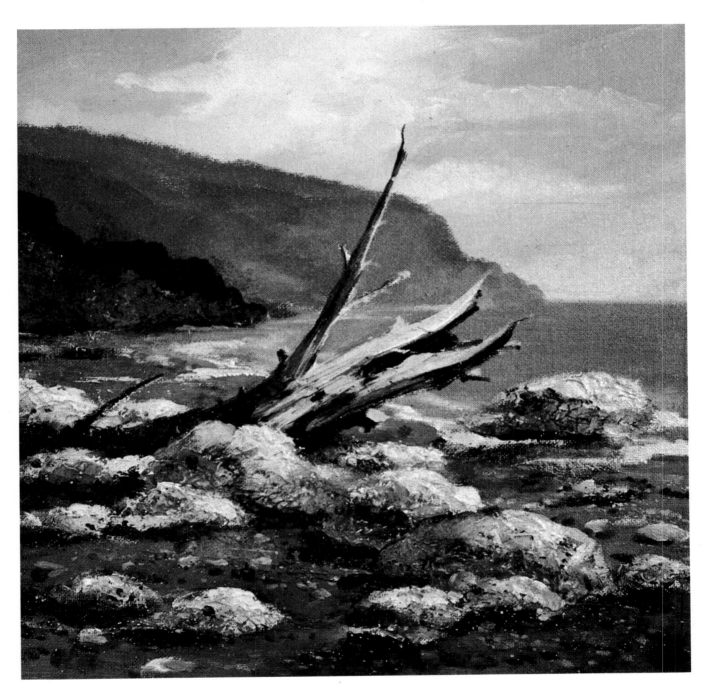

Step 7. To brighten the sunlit tops of the rocks, the artist blends a thick mixture of yellow ochre, burnt sienna, and white, plus acrylic gel medium, on his palette. He drybrushes this pale mixture across the tops of the rocks. The artist applies this sunny mixture to the bright areas of the driftwood with long strokes that follow the grain of the weathered trunk and branch. He then drybrushes a dark mixture of burnt sienna and ultramarine blue, diluted with liquid medium, over the shadows of the driftwood and along the shadowy edges of the rocks. With each stroke, the textures become rougher. To push the dark, distant rock formation further into the background, the artist scumbles a cool mixture of phthalocyanine green, yellow ochre, and burnt umber over the dark shape. He decides that there are too many rocks—he needs more beach to contrast with the rocky forms—so he paints out one rock in the lower left with the dark sand mixture he used in Step 4. To break up the rocks into different shapes and sizes for greater variety, he divides them with dark strokes, and then builds up their tops with the thick, sunny mixture. With this same mixture, he paints scattered pebbles on the beach, adding more white to paint the foamy edge of the water. With tiny touches of ultramarine blue and burnt sienna, he adds shadows beneath some large pebbles and scatters touches across the foreground to suggest smaller pebbles.

Step 1. Instead of mixing your colors on the palette, you can apply them directly to a wet painting surface. This is the *wet-into-wet* technique. The artist draws his subject on a heavy sheet of cold-pressed watercolor paper. He then brushes clear water over the sheet until the surface is wet and shiny. With his largest flat brush, he covers the sky and lake with broad strokes of yellow ochre that quickly blur into one another. While the surface is still wet, he picks up cerulean blue and burnt umber with the same brush and sweeps this tone across the upper sky. The new strokes blur into the wet undertone, creating a dark-to-light gradation.

Step 2. The moisture is gradually sinking into the fibers of the paper and starting to evaporate at the same time. The paper is still wet and shiny, but not as wet as before. Blending ultramarine blue, naphthol crimson, and water on his palette, the artist brushes in the shapes of the distant mountain. As these darker strokes hit the paper, they blur slightly on the wet surface, but the strokes hold their shape more firmly because the paper isn't quite as wet. Notice how the artist brushes more color into the dark peak of the mountain and less color into the base. The mountain is a mixture of the warm underlying tone and the cooler overtone fusing on the wet paper.

Step 3. The paper is *almost* dry now, but there's still a faint shine on the surface. Across the center, the artist brushes vertical strokes of phthalocyanine green, burnt sienna, ochre, and a little white (for mist) at the base of the distant trees. These tree strokes blur slightly on the damp paper. At the right, the artist brushes in the dark shore with burnt sienna, viridian, and ultramarine blue. The top of this new shape blends softly into the wet tone of the trees above. Now the paper has lost its shine. This means that additional strokes will no longer blend smoothly with the other wet colors, but will dry with a ragged, unsightly edge. So the artist lets the picture dry thoroughly.

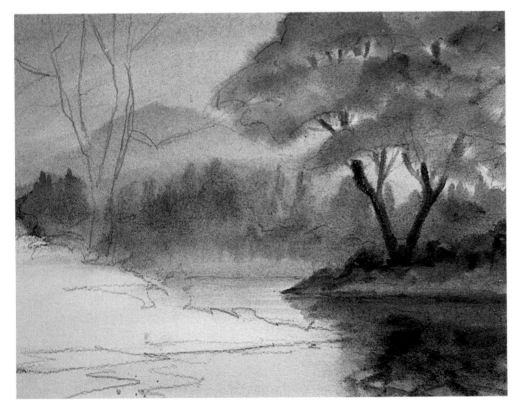

Step 4. The artist now brushes a fresh coat of clear water over the dry paper. Because acrylic dries waterproof, the underlying color doesn't dissolve. First he blocks in the foliage with broad strokes of phthalocyanine green, burnt sienna, and yellow ochre. Then he paints the dark reflection beneath the shore with burnt sienna, ultramarine blue, and yellow ochre. As the paper gradually dries, he darkens this mixture with more ultramarine blue to paint the trunks, branches, and their reflections in the darkness below. He saves these more distinct strokes for the very end, when the paper is just barely wet.

Step 5. The artist allows the entire painting to dry thoroughly again, since the remaining strokes must be applied to dry paper. He paints the dark shoreline at the left with burnt sienna, phthalocyanine blue, and yellow ochre—with a few touches of cadmium red light in the warmer areas. Then he suggests the reflection of the shore and the bare trees with a *very* dark mixture of phthalocyanine blue and burnt sienna. Note that the triangular shape of the shore is a kind of wet-into-wet mixture—with thicker paint. The artist paints the darks first; then he brushes the warmer, slightly lighter tones into the dark, wet undertone. The action of the brush blends the colors.

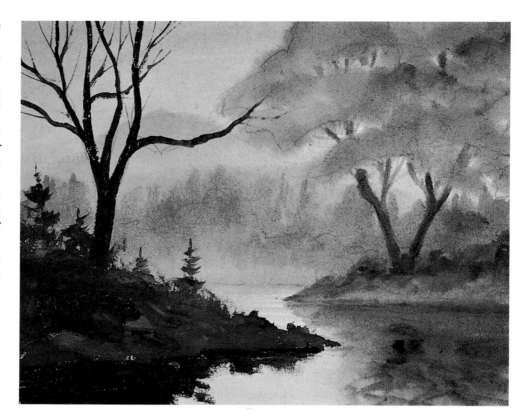

Step 6. More branches and slender twigs are added to the silhouette of the dark tree at the left with the original mixture of phthalocyanine blue and burnt sienna, diluted with enough water to permit precise brushstrokes. Within the blurred masses of foliage at the right, the artist adds soft shadows with a mixture of phthalocyanine green, burnt umber, yellow ochre, and a little white. With this same mixture, he adds more branches to these trees, indicates a few low evergreens on the shore, and places more strokes in the water to make the reflections more distinct.

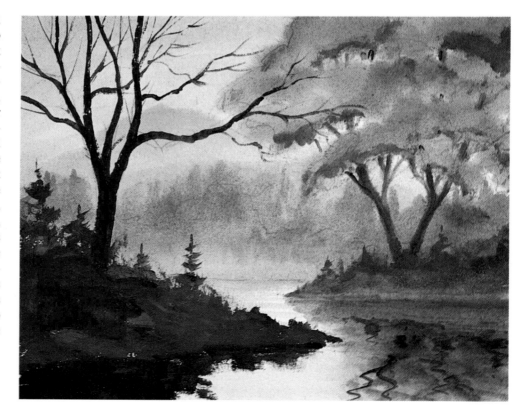

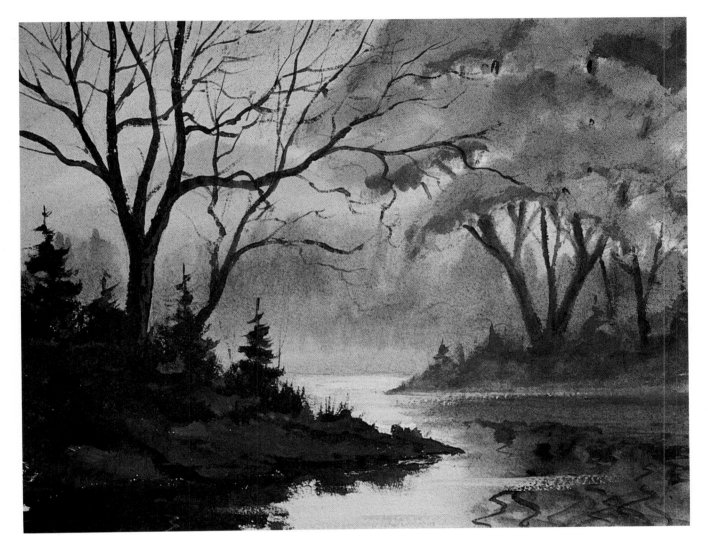

Step 7. On the dark shore at the left, the artist adds a second tree that leans over the water. He paints the trunk and branches—and adds a few more branches to the other tree—with phthalocyanine green, burnt umber, and enough water to make the paint flow smoothly. Darkening this mixture with a touch of phthalocyanine blue, he adds another low evergreen to the shore, and animates the silhouette of the dark shore with slender strokes that suggest leafless branches, shrubs, and weeds. To brighten the soft light on the calm surface of the water, the artist drybrushes horizontal strokes of yellow ochre and white. Now there's a more distinct flash of light on the pond beneath the far shore—at the very center of the picture—and there are also sparkling streaks of light in the dark reflections of the trees in the foreground. Although most of the picture is painted wet-into-wet—with the colors blended together on the wet surface of the watercolor paper—the artist knows that a picture may lack solidity if it's painted *entirely* in the "wet-paper technique." Instead, the soft, blurred forms—painted on wet paper—need the contrast of a few sharply defined forms, which must be painted on dry paper. Thus, the dark, distinct forms of the landscape at the left are necessary to balance the softer forms that appear in the rest of the picture. And these softer forms seem more magical and remote because of the contrast with the hard-edged shapes of the near shore. For wet-into-wet painting, watercolor paper or board is usually the best surface because it absorbs and holds water more effectively than the less absorbent surface of canvas or a gesso panel.

Step 1. In the nineteenth century, the Impressionist and Post-Impressionist painters discovered another method of mixing colors. They built up their pictures with a mosaic of individual strokes painted side-by-side, over one another, and *into* one another—directly on the painting surface. Over a pencil drawing on illustration board, the artist blocks in the sky with short, distinct strokes of yellow ochre and white. Over these, he places strokes of ultramarine blue and white, cadmium red light and white, and burnt sienna with a little ultramarine blue and white. For the soft tone at the horizon, the artist adds much more white to this last mixture.

Step 2. He fills the upper sky with cool strokes of phthalocyanine blue, naphthol crimson, and white; and with warmer strokes of burnt sienna, naphthol crimson, yellow ochre, and white. He adds more white to these mixtures for the interplay of warm and cool strokes just above the horizon. Notice how he works carefully around the shapes of the trees, leaving the trunks, branches and foliage bare for the moment. Finally, he repeats the warm and cool sky mixtures in the water.

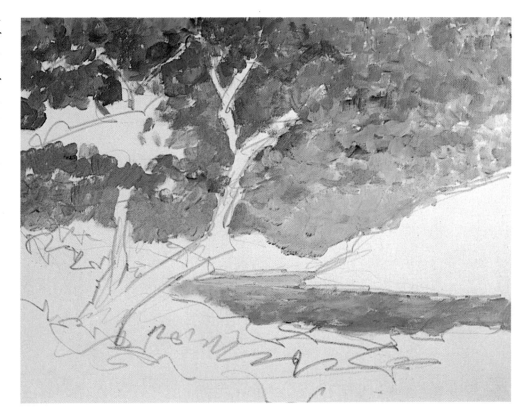

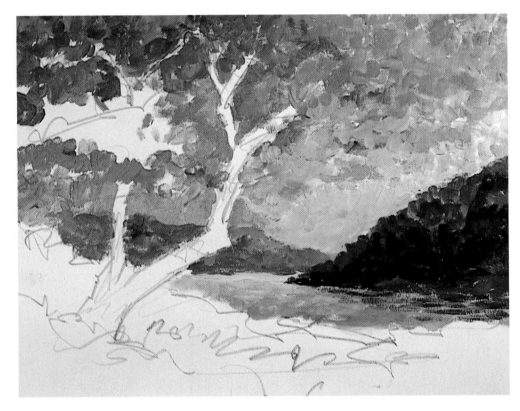

Step 3. The bright color of the distant shore at the left is painted with various combinations of ultramarine blue, naphthol crimson, a little yellow ochre, and white. As you can see, some strokes contain more crimson, while others contain more blue, and still others contain more white. The darker, wooded slope at the right is painted with deeper mixtures of these same colors, intermingled with strokes of burnt sienna and phthalocyanine green in the shadows. These dark tones are carried down into the water with slender, horizontal strokes that suggest reflections.

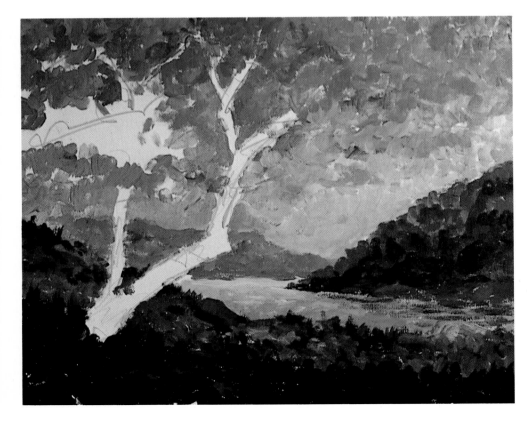

Step 4. The grassy foreground is first covered with strokes of phthalocyanine green, burnt sienna, yellow ochre, and a little white. Then, while these strokes are still wet, the artist adds darker strokes of varying combinations of ultramarine blue, phthalocyanine green, and cadmium red light. (The warmer strokes contain more red, while the cooler strokes contain more blue or green.) The artist doesn't consciously attempt to blend his strokes. But each fresh stroke tends to create an optical mixture with the dried color beneath—or creates a wet-into-wet mixture if there's wet color beneath. And each stroke is allowed to hold its own distinct shape.

Step 5. The trunk is painted with dark and light strokes of phthalocyanine blue, burnt umber, yellow ochre, and white. The lighter strokes obviously contain more white and yellow ochre, while the darker ones contain more blue and burnt umber. Because the artist lets each stroke stand unblended, his brushwork captures the rough texture of the bark. Then he moves into the upper area of the painting to block in the foliage with a dark mixture of phthalocyanine green, burnt sienna, and a bit of phthalocyanine blue. The shapes of the foliage are built up with a mosaic of individual strokes.

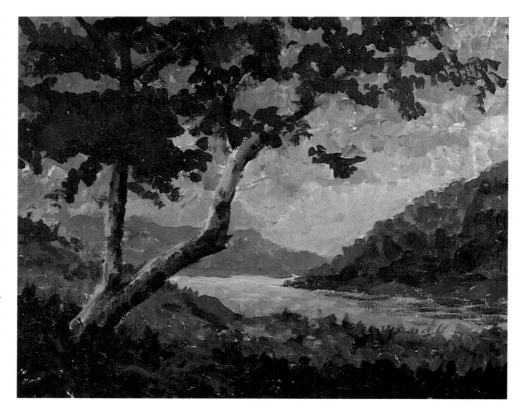

Step 6. The blossoms on the tree are small touches of three different mixtures. The cool blossoms in shadow are a blend of cerulean blue, yellow ochre, and white. The warmer blossoms are mainly yellow ochre and white, with a hint of burnt sienna. And the bright blossoms in direct sunlight are *almost* pure white with a drop of cerulean blue. The artist adds branches and strengthens the shadows on the trunks with phthalocyanine blue and burnt sienna. Then he brightens the sunlight on the trunks with the mixtures he's used for the blossoms. He carefully leaves gaps in the foliage to allow the sky to shine through.

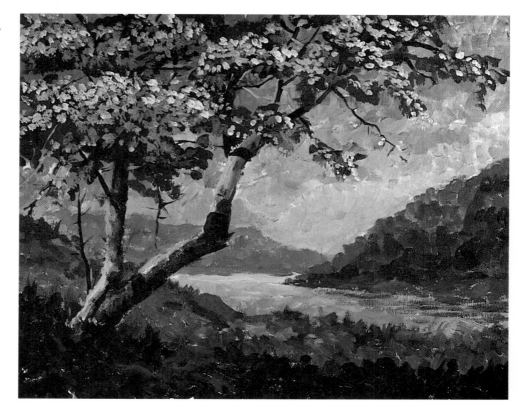

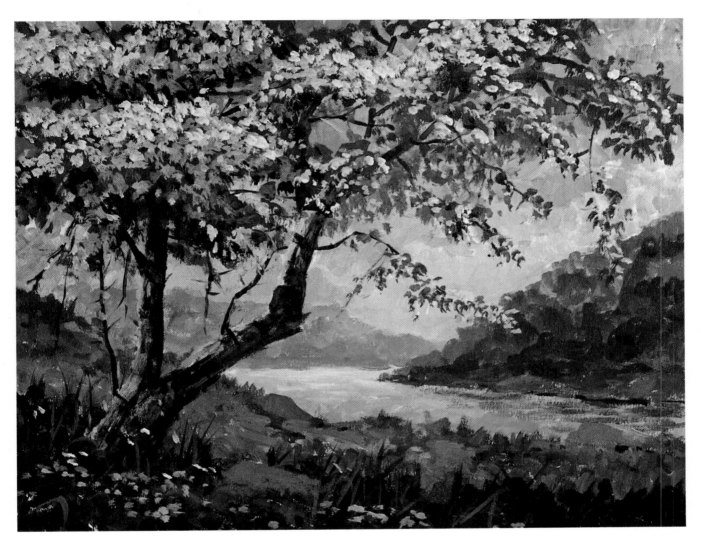

Step 7. With small strokes of phthalocyanine green, burnt sienna, yellow ochre, and white, the artist extends the leaves across the sky. Among the leaves, he adds more blossoms with the same three floral mixtures he used in Step 6 so that we now see rich masses of flowers in the sunlight. Among the grass at the bottom of the picture, tiny strokes of these mixtures become wildflowers on the shadowy ground. Within the grass, the artist adds rocks with broad strokes of burnt umber, cadmium yellow light, ultramarine blue, and white. Blending more white into this mixture, he adds warm strokes to the sunlit edges of the tree trunk. He blends phthalocyanine green, and burnt sienna with a touch of phthalocyanine blue for the dark grass around the tree and rocks. Then he adds white to this mixture for the paler blades of grass. Finally, a few dark strokes are added to the tree trunks with phthalocyanine blue and burnt umber, to indicate the cracks in the bark. Now compare the completed picture with its early stages. In the first few steps, the mosaic of strokes may have seemed harsh, chaotic, and fragmentary. But as the artist gradually built up his colors, stroke over stroke, the painting began to knit together. Ultimately, all the strokes stay in their places, forming a unified, harmonious picture that's full of color, shimmering light, and lively brushwork.

Warm and Cool. A successful color scheme not only achieves color harmony, but leads the viewer's eye to the focal point of the picture. Thus, the warm tone of the dead tree—a mixture of burnt sienna and cadmium yellow light—captures the viewer's eye because the tree is surrounded by cool shadows on the snow and the cool tone of the ice.

Bright and Subdued. Another way to carry the viewer's eye swiftly to the center of interest is to plan a contrast of bright and subdued color. Here the spot of brilliant sunlight is surrounded by the subdued colors of the shadowy road and surrounding trees. The artist also paints the darks with semi-transparent scumbles and the lights with opaque color.

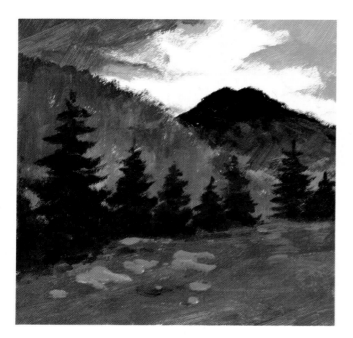

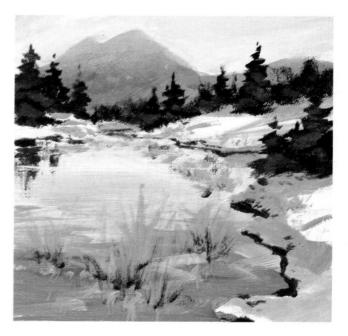

Light Against Dark. The artist saves his strongest contrast of values for the focal point of this landscape. The dark peak is silhouetted against the light shape of the cloud to bring the viewer's attention directly to the upper right. The light tone of the cloud is the white paper itself.

Leading the Eye. To carry the viewer's eye from the bottom of the picture to the mountains, the warm tones of the weeds create a curving path from the foreground to the center of interest. Next to this warm tone, a cool complementary tone follows the same path. The two complementary colors enhance each other as the eye moves into the picture.

Cubical Form. Even though this book is about color, there's no color without light. So you must understand how light and shade behave on form. This blocky rock formation, is roughly cubical. The top plane receives the direct light. The right side plane is a halftone—midway between light and shadow. And the left side plane is in shadow. There's also a cast shadow on the snow.

Rounded Form. Many natural forms, like this dune, resemble spheres or hemispheres over which the light travels as it would over a ball. From left to right, you see the typical sequence of four tones: the light, the halftones between the light and shadow, then the shadow, and finally the paler tones of the reflected light within the shadow.

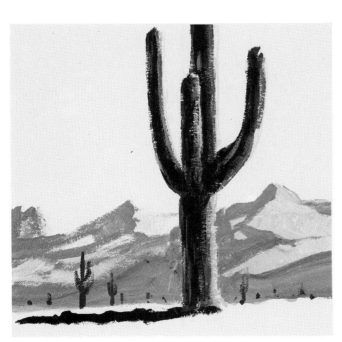

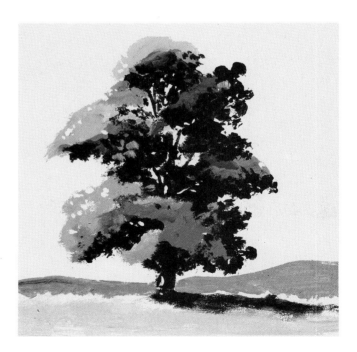

Cylindrical Form. Growing forms, like a tree trunk or this cactus, are often cylindrical. From right to left, you can see light, halftone, shadow, and reflected light at the shadow edge. The lighted areas are illuminated by the sun, while the reflected lights come from some secondary source—like the sand—that acts like a amirror, bouncing light back into the shadow.

Irregular Form. Although many forms—like this tree—are nongeometric, you can still see the same gradation of tones. Since the light comes from the left, you see the light, halftone, and shadow on the leafy masses. It's difficult to see reflected lights, but there's a cast shadow on the ground opposite the lighted side.

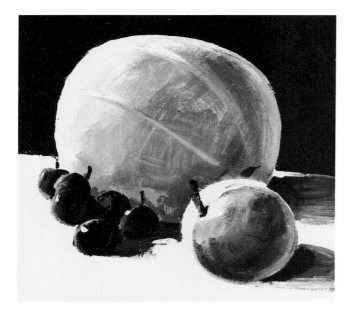

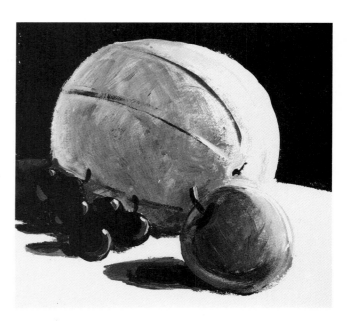

Side Lighting from the Left. When the light strikes the shapes of the fruits from the left, the gradation of light and shade moves from left to right. On the lighted sides of some of the grapes, there's a bright *highlight*—the point that receives the most intense light. Notice the cast shadows to the right of each form.

Side Lighting from the Right. Now the light strikes the fruit from the right, so the gradation of light and shade is reversed. You can still see those bright highlights on the lighted sides of the grapes, and the cast shadows on the opposite sides. Lit directly from the side, most of the form is in halftone and shadow, as you see clearly on the melon and the apple.

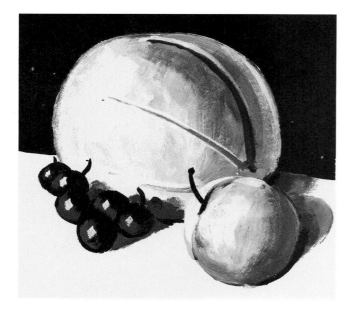

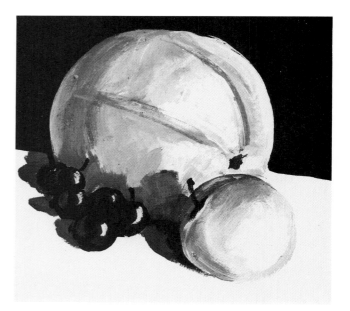

Three-Quarter Lighting from the Left. The light no longer comes from the side, but comes from above and behind your left shoulder. Now there's more light on the form, but less halftone and shadow. The light moves diagonally from left to right, and so do the cast shadows.

Three-Quarter Lighting from the Right. When the light moves diagonally over your *right* shoulder, the sequence of tones is reversed. There are large lighted areas and halftones on the forms, and rather slender shadows with reflected lights at the edges. Notice how the apples and grapes throw cast shadows not only on the table, but on the big shape of the melon behind them.

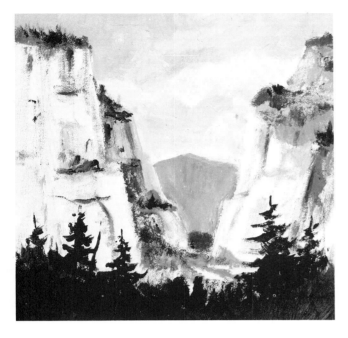

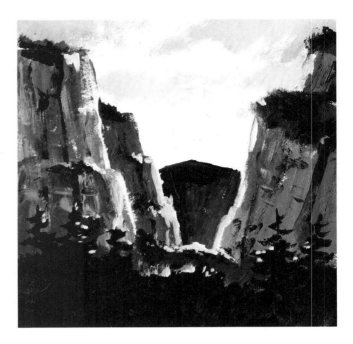

Front Lighting. It's worthwhile to spend a day painting the effects of the changing light on landscape subjects. When the light comes from directly behind you, it strikes the fronts of the cliffs. It's typical of front lighting that most of the areas are illuminated, with just slender shadows around the edges and within the cracks.

Back Lighting. The sequence of tones is reversed when the sun is behind the cliffs. Now the forms are mainly in shadow, with slender rims of light around the edges. (The effect is sometimes called *rim* or *edge lighting*.) You can accentuate the contrast by painting the lights with thick, opaque color, and painting the shadows with thin, semi-transparent color.

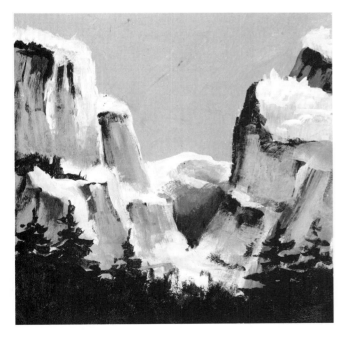

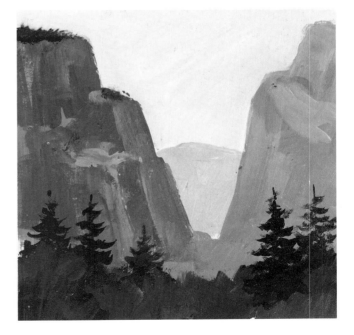

Top Lighting. When the light comes from directly overhead, the tops of the forms are brightly lit and the sides tend to be in shadow. There are dark tones in the concavities just beneath the tops of the cliffs. Making small monochrome studies like these will show you how many pictorial ideas you can get from a single subject.

Diffused Light. When there's a veil of fog, mist, or rain over the sun, the light is diffused. There's less distinction between light, halftone, shadow, and reflected light. But looking closely at this landscape, you can still see a subtle contrast between the light and shadow planes, although the halftones and reflected lights are almost invisible.

Sunny Day. Just as it's useful to paint the same subject at different times of day, you'll also learn a lot by painting the same subject under different weather conditions. On a sunny day, there are strong contrasts between light and shadow, and sharply defined cast shadows on the snow. Although there are extreme lights and darks, you can also see two middletones, one light and one dark. The distinctions between the values are obvious in bright sunshine.

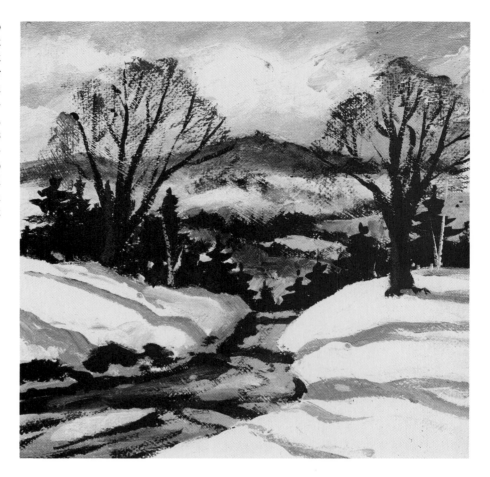

Cloudy Day. Under a cloudy sky, some parts of the landscape are darkened by the shadows of the clouds, while other parts are caught in the sun that breaks through. Thus, there are interesting, distinct, and unpredictable patches of light and shadow on the land. You can see this effect on the snowy foreground and the far hill. You can use these patches of cloud shadows and sunlight creatively, subduing some areas of the landscape and spotlighting others. Notice how the artist has painted the shadow areas of the snow in thin color, piling on thicker strokes in the lighted areas.

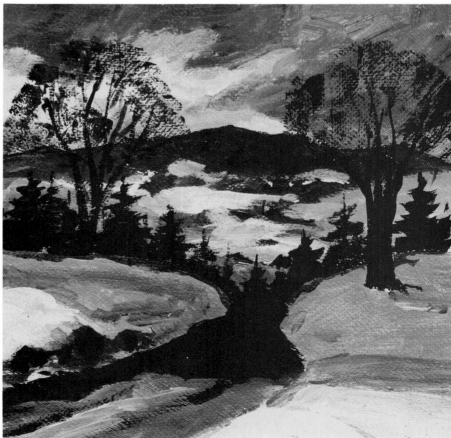

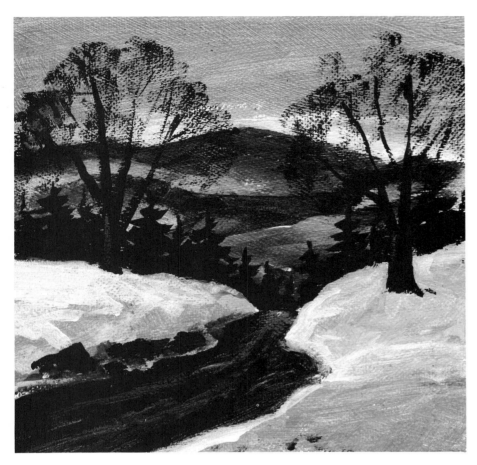

Overcast Day. When there's a solid screen of clouds over the sun, without those dramatic breaks in the sky, the entire landscape is generally grayer. On an overcast day, most tones come from the middle and lower parts of the value scale. There are almost no bright lights. Occasionally, there's a slight break in the clouds just above the horizon, and this light is reflected on the snow, as you see here. But if you don't find that hint of light at the horizon, there's nothing wrong with *inventing* it to introduce a bit more tonal contrast.

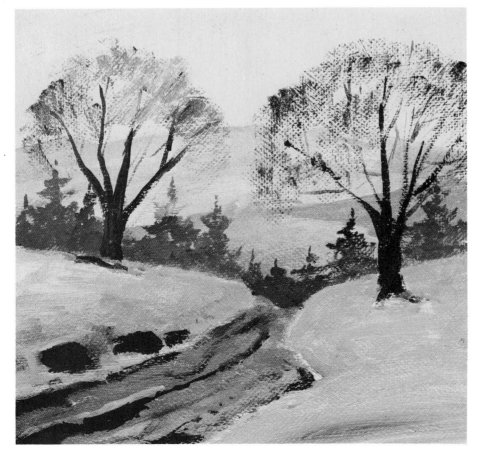

Hazy Day. On a hazy day, there's a soft screen of water vapor over the entire landscape. Oddly enough, a hazy day can actually be a bright day, particularly if you're painting the early morning haze that diffuses the rays of the rising sun. That's what's happening here. Typical of a hazy day, there are no gradations of light and shade on the forms. Each shape—tree, rock, snowbank—is a flat tone. The haze lightens *all* the tones, so that even the dark trees are pale. Most of the tones come from the upper part of the value scale, which means that you've got to add a lot of white to your mixtures.

High Key. As you paint monochrome studies outdoors, you'll begin to discover the phenomenon that painters call *key*. A landscape is a high-key subject when you can paint it almost entirely in values that come from the upper and middle points of the value scale. In other words, the lights and middletones are *all* quite pale, while even the darks are medium grays. This coastal landscape, painted in a thin fog, is an example of a high-key subject.

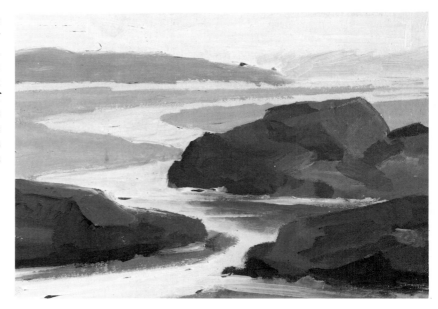

Middle Key. When the fog begins to melt away and the sunlight becomes stronger, more of the values in this subject come from the middle of the value scale, with only the strong lights coming from the upper part. With the changing light and weather, this high-key subject has become a middle-key subject. You'll find that most paintings are in this key.

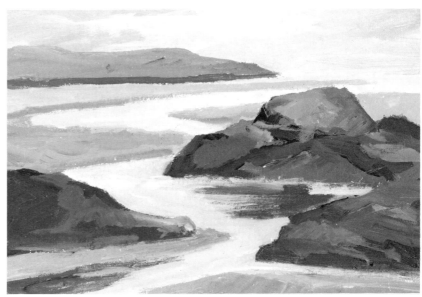

Low Key. As the light begins to fade toward the end of the day, the whole landscape darkens. Now the most important values in the rock and the distant shore come from the lower part of the value scale. As you've guessed by now, this is a low-key landscape. Although not every subject has a distinct key that you can identify, many do. If you *can* identify a specific key, this will help you achieve the right values when you mix your colors. It will also help you plan the value scheme of the landscape with much more accuracy.

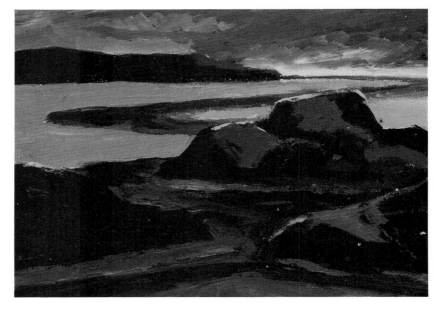

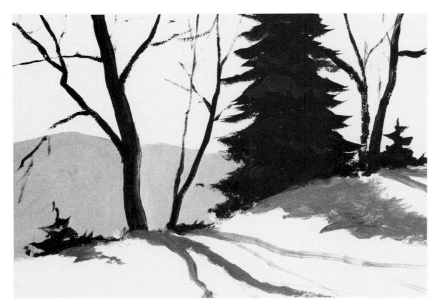

High Contrast. Besides *key*, another factor that you'll discover as you work outdoors, painting the same subject under different light conditions, is *contrast*. When the light is bright and clear, the tones of the landscape are likely to come from the top and bottom of the value scale, as well as from various places between these two extremes. Here, the trees are strong dark values, the sky and snow are light values, and there are two distinct middletones—one lighter and one darker. Because there are sharp contrasts between values, this is a high-contrast subject. But the tones are so diverse that you can't identify it as having a specific key.

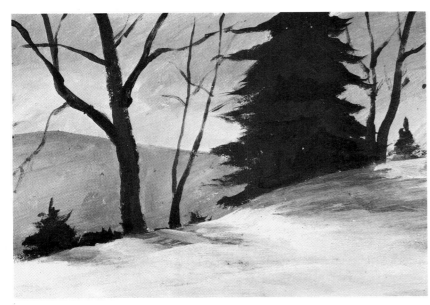

Medium Contrast. On a cloudier day, the darks in this landscape are paler, and the lights darker. In short, there's less contrast between light and dark—and even less contrast between the two middletones, which now may look like one value. This landscape is a medium-contrast subject. It also happens to be a middle-key subject, but medium contrast and middle key don't necessarily go together. *All* the studies on the opposite page are actually in the medium-contrast range.

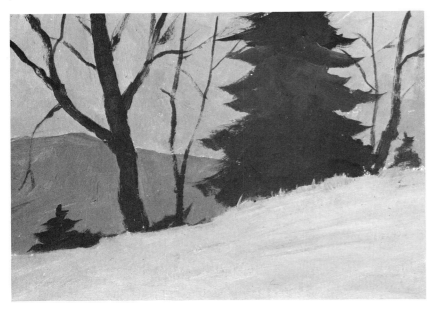

Low Contrast. On a very gray day or seen through a thick haze, the darks appear still lighter, the lights seem darker, and there's even less contrast between darks, lights, and middletones. The landscape is transformed into a low-contrast subject. Bear in mind that it would *also* be a low-contrast subject on a foggy day, when most tones are pale, or at nightfall, when most of the tones are dark.

Step 1. To paint a high-key landscape, the artist brushes a sheet of illustration board with a delicate value that represents the lightest tone in the picture. Next comes the brush drawing, which may seem rather dark, but will soon disappear beneath the opaque tones that come next. He blocks in the darker tones of the sky with a pale middletone, and then repeats that pale middletone in the reflections along the edge of the shore.

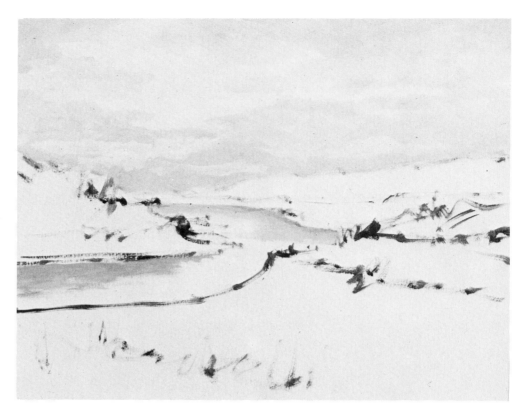

Step 2. Because it's important to keep the entire picture in a high key, the artist works gradually from light to dark. His next step is to block in the darker middletone of the distant shore. He repeats this tone in the reflections along the edges of the shore. He blocks in a light middletone on the shadow side of the shore at the left. On the dune in the foreground, he begins with a dark tone at the edge, then blends this softly into the pale shadow that curves down the side of the dune.

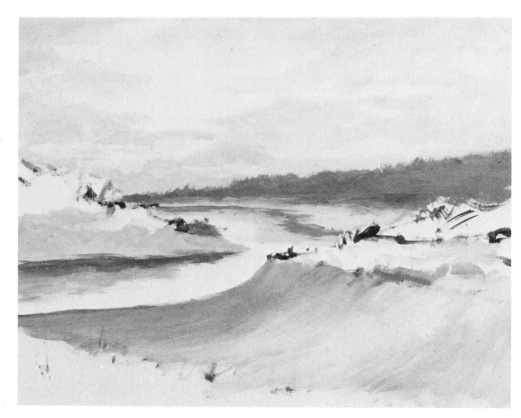

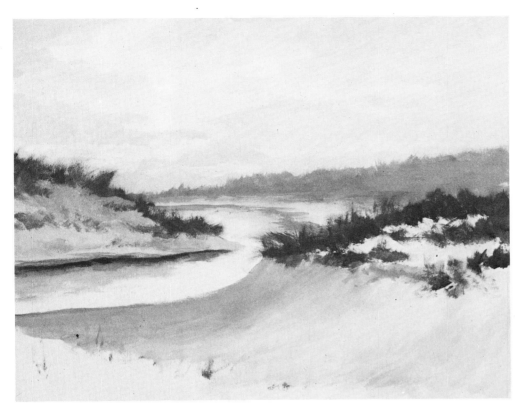

Step 3. The artist adds the grass on the top of the dunes with dark tones. He carries this dark tone below the shore at the left with a slender line that reinforces the reflection in the water. He brushes the pale middletone over the entire dune at the left. By the end of Step 3, the painting contains all four major values: the light value in the sky and water, the pale middletone in the sky and the dunes, the darker middletone on the distant shore and at the edge of the foreground dune, and the dark grass on top of the nearby dunes.

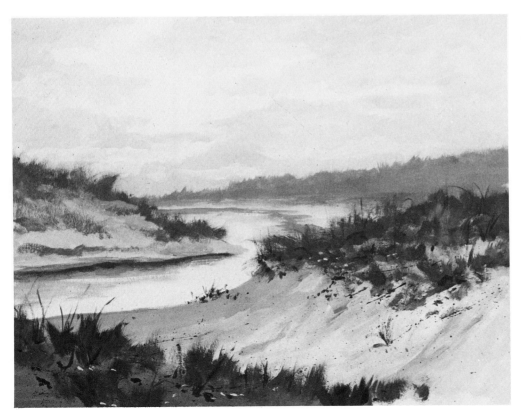

Step 4. The artist adds the rest of the beach grass on the dunes and in the immediate foreground. He varies these tones by introducing a few strokes of the dark middletone. Detail is added to the concave side of the foreground dune with delicate touches of the dark middletone. Finally, he dips his brush into the strongest dark to strike in a few individual blades of grass. (These last strokes actually represent a fifth value, but they're inconspicuous and simply melt away into the surrounding darkness.)

Step 1. For this picture, in which darks will predominate, the artist brushes two coats of acrylic gesso over a sheet of illustration board. One coat runs from top to bottom, and the other from side to side. The gesso is applied thickly so that the strokes, as they cross, produce a texture something like canvas. The rough texture of the dry gesso produces a slightly shadowy surface that will enhance the shadowy tone of the painting. When the painting surface is absolutely dry, the artist begins his preliminary pencil drawing.

Step 2. Since the sky is the source of the light and therefore influences the entire picture, the artist begins by painting the sky. He blocks in the lighter middletones—although there are subtle variations in value as he adds slightly darker strokes to suggest clouds against the overcast sky. As he moves down toward the horizon, he lightens his strokes with more white. This pale gray will be the lightest value in the picture.

Step 3. The artist introduces the darker middletone of the distant shore at the right. Then he blocks in the shore at the left with a faintly darker version of the same middletone. He also brushes this dark middletone into the foreground water. Picking up the lighter tone of the sky, he brushes this across the water above the log—and blends it with the darker middletone in the foreground. Just where the sky meets the lake, he blends the palest value into the water. Then he introduces the darkest value into the trees and the shadows beneath the trees.

Step 4. He adds more dark shadows to the shore at the left and carries the dark strokes down into the water to represent the reflections. He strengthens the dark tone of the water in the foreground. Then he blocks in the floating log with the light middletone. He adds shadows and details on the log with the darker middletone and the dark. Then he paints the light-struck edges of the shapes with a few pale strokes of the lightest value. He solidifies the shapes of the trees on the shore by adding dark middletones. Finally, he paints a few light streaks in the water with the same pale tone that appears above the horizon.

Step 1. To accentuate the contrasts between light and dark, the artist first brightens the canvas board with an extra coat of acrylic gesso. Then he brushes in the shapes of the composition with dark strokes that will soon disappear beneath the dark values in succeeding steps. As before, the artist begins by painting the sky in a light value. He adds just a bit more white for the clouds, but the values of the sky and clouds are so close that they register as a single pale tone.

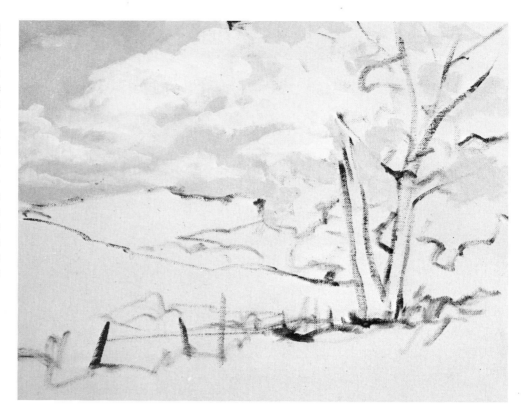

Step 2. The artist blocks in the distant hills with two values: a darker middletone for the foliage at the top of the hill, and a lighter middletone for the sloping side of the hill. We begin to see that the pale value of the sky actually represents the lightest tone in the picture. For the moment, the artist is keeping all the values fairly light so that he can darken them later on to accentuate the contrasts.

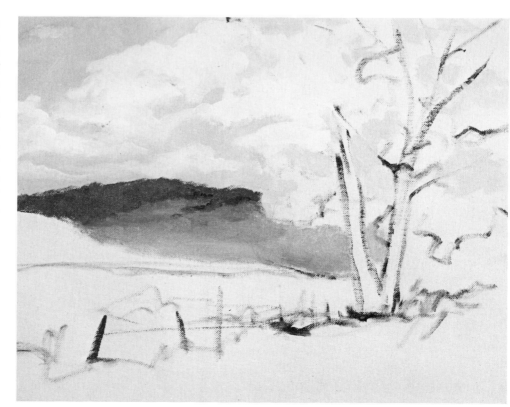

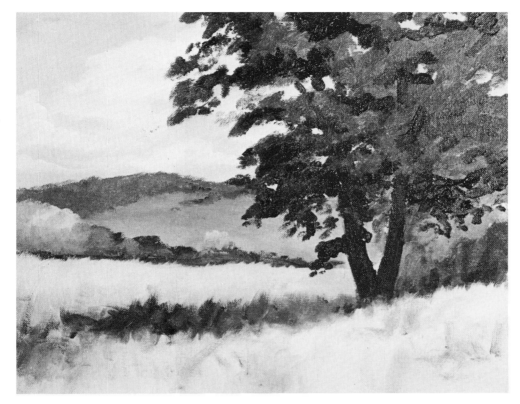

Step 3. At the foot of the hill, the artist paints a row of trees. He starts with a sunlit patch at the left and ends with a dark middletone like the one on top of the hill. He blocks in the foliage of the big tree with the same middletone and then carries this tone across the grass to suggest the shadow of the tree. He paints the distant sunlit field and the sunny foreground with the same value as the sky. Then he begins to block in the darks on the tree trunk and in the shadows beneath the masses of foliage.

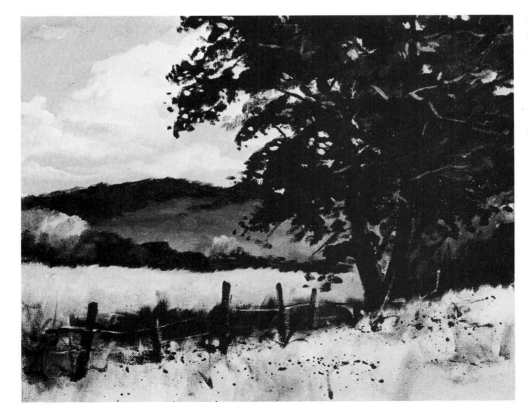

Step 4. Now the artist strengthens all the tones. He darkens the foliage at the top of the hill, the row of trees at the bottom of the hill, and the strip of shadow across the foreground grass so that they're all a dark middletone. He also darkens the side of the hill so that it's now a light middletone, distinct from the pale sky and the sunlit field. Finally, he strengthens the two tones on the tree, so that they're clearly a dark middletone and a dark.

Step 1. After defining the shapes of the wooded headlands with pencil lines on a sheet of illustration board, the artist paints the sky and water in a single operation. He starts with a pale value in the sky and gradually darkens his strokes as he moves down into the water. It's a foggy day, so the sky and water seem to flow together. At this stage, you may think that you're seeing a lighter and a darker middletone—but things will change.

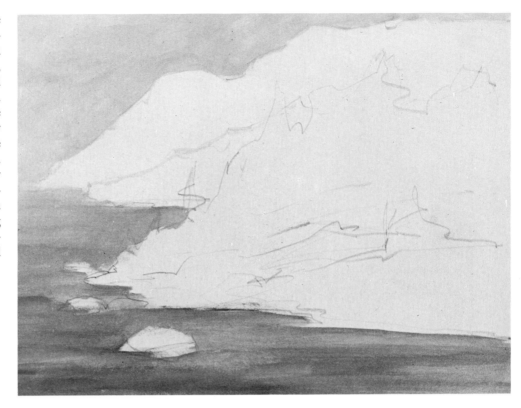

Step 2. The artist blocks in the most distant headland with a value that's slightly darker than the sky, deepening the tone a bit to suggest the trees on the crest. Then he paints the triangular shape of the headland in the middleground with a faintly darker value, again deepening the tones to indicate the trees on the slopes, and lightening the values gradually at the base of the rocks to suggest a low-lying mist. He paints the rocky shore in the foreground with a similar value, and blocks in the dark rock in the lower left. The value scheme of the picture still isn't clear to the viewer, but the artist knows what he's doing, as you'll see in a moment.

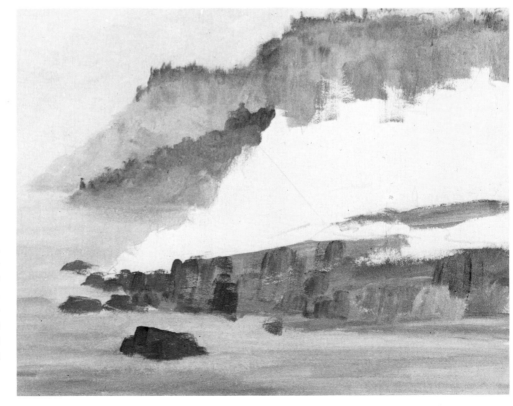

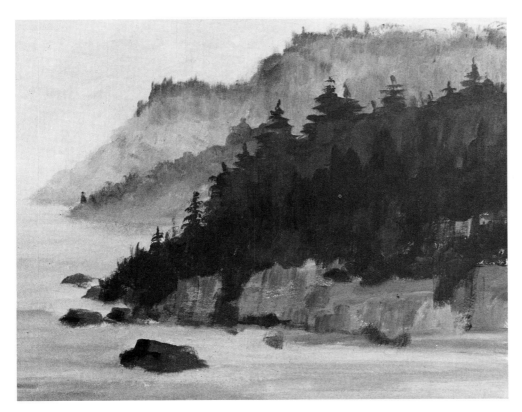

Step 3. When the artist blocks in the dark trees, the logic of the values becomes clear. The lightest tone is the sky, which blends into the lighter middletone in the foreground water. The most distant headland is the same light middletone, with a hint of the darker middletone at its top. This darker middletone reappears in the small triangle of the headland in the middleground and in the foreground shore. The strongest darks are the trees. They're actually *two* dark values, but they're so close that they register as a single dark tone when you look at the picture with half-closed eyes.

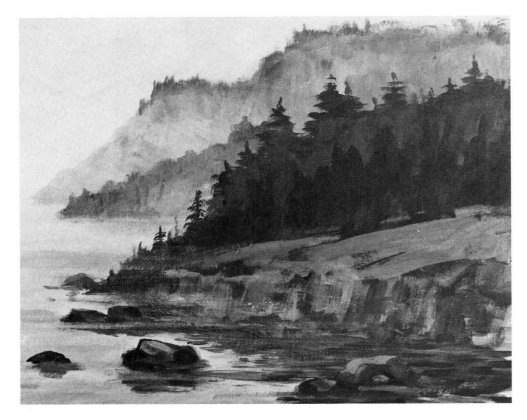

Step 4. The artist completes the complex tones of the foreground. He brushes the lighter middletone over the top plane of the shore. Then he alternates dark strokes with middletones on the shadowy sides of the shore and in the reflections. The rocks are further developed with similar combinations. In the finished picture, none of the darks come from the bottom of the value scale and none of the lights come from the top. Because all the values here are quite close to one another on the scale, this coastal scene is a low-contrast painting.

Sketch for Demonstration 1. Planning your values is so important to the success of any picture that you should develop the habit of making little value sketches before you begin an acrylic painting. Such sketches can be crude and scribbly, just as long as they give you a clear idea of the distribution of values in the picture. In this tiny pencil sketch, the artist decided how he'd use values to create a sense of aerial perspective in Demonstration 1.

Sketch for Demonstration 4. When you paint outdoors, take along a pocket sketchbook and a thick pencil or a stick of chalk that will make broad strokes. Working quickly, make several sketches and choose the value scheme that looks best. In this value sketch for the painting in Demonstration 4, the rocks, trees, and waterfall may be recognizable only to the artist. But the sketch clearly establishes the location of the darks in the foreground, the two middletones along the far shore, and the light tones of the sky and water.

Sketch for Demonstration 6. This value sketch actually had two purposes. As usual, the artist wanted to establish the distribution of lights, darks, and middletones. But he also used the sketch to record the shapes and locations of the fast-changing clouds. Obviously, this wasn't meant to be a precise drawing of each cloud. But a sketch like this one helps to fix the forms and placement of the clouds in the artist's memory, so he can paint them convincingly, even though the sky will change.

Sketch for Demonstration 9. As you remember, Demonstration 9 shows the wet-into-wet technique, which means that most of the shapes are soft and slightly blurred. In the preliminary sketch, the artist takes extra care to plan the contrast between the strong hard-edged darks and the pale, soft tones that fill the rest of the picture. Be sure to save all your value sketches—especially the *rejected* ones—for possible future use. Your little pocket sketchbooks will contain a wealth of ideas for future paintings.